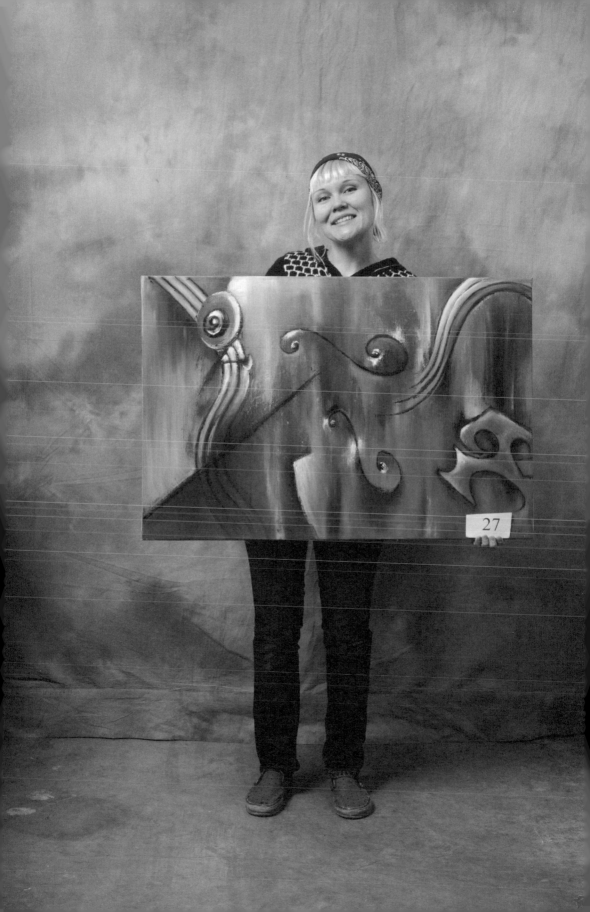

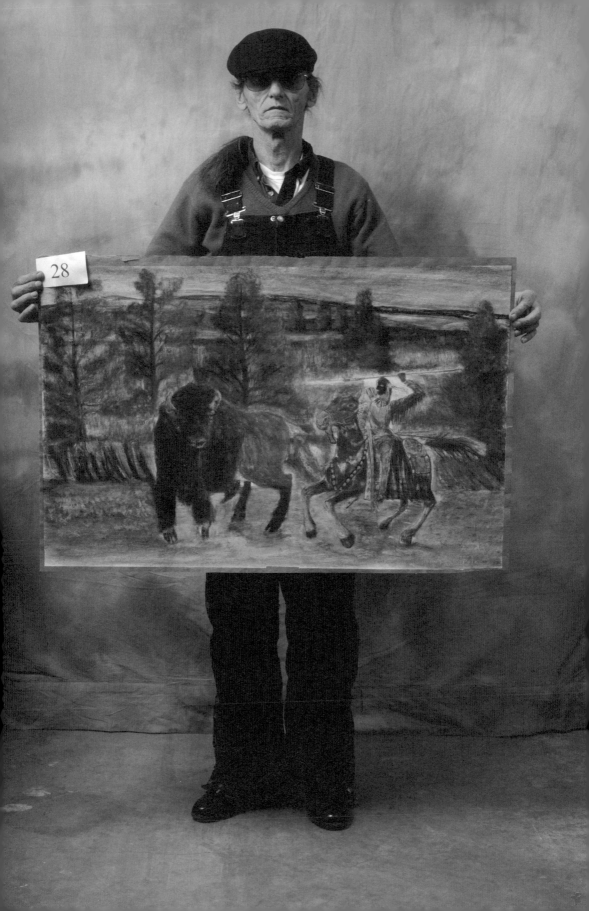

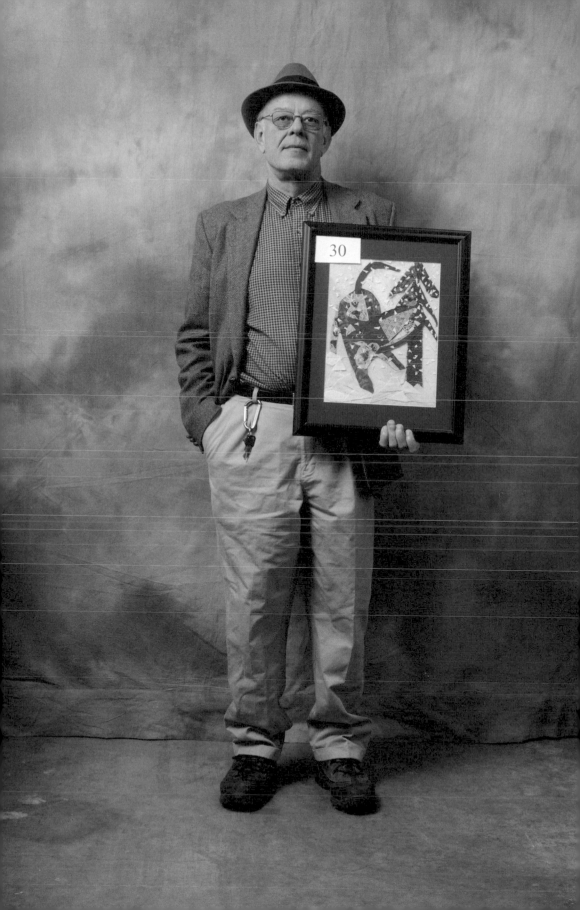

~PEOPLE'S~ BIENNIAL 2010

A Guide to America's Most Amazing Artists

Harrell Fletcher & Jens Hoffmann / Independent Curators International

CALEB BELDEN

MARY BORDEAUX

LAURA DEUTCH

ALLY DROZD
with Judge Evans and the Portland Community Court

JORGE "EL CHE" FIGUEROA

GARY A. FREITAS

SYLVIA GRAY
with the Elsewhere Collaborative

JIM GROSBACH

NICOLE HARVIEUX

WARREN HATCH

JAKE HERMAN

MAIZA HIXSON

DAVID HOELZINGER

HOWARD KLEGER

ELLEN LESPERANCE

CYMANTHA DIAZ LIAKOS

JONATHAN LINDSAY

DENNIS NEWELL

BOB NEWLAND

RAYMOND MARIANI

ALAN MASSEY

JENNIFER MCCORMICK

JIM MCMILLAN

BEATRICE MOORE
*and the Mutant Piñata Show (with piñatas by Chris Clark, Tom Cooper,
Ana Forner, Mike Maas, and Koryn Woodward)*

JOSEPH PEREZ

BERNIE PETERSON

BRUCE PRICE

DAVID ROSENAK

JJ ROSS

ANDREW SGARLET

ROBERT SMITH-SHABAZZ

RUDY SPEERSCHNEIDER

ANDREA SWEET

JAMES WALLNER

PRESLEY H. WARD

PAUL WILSON

～CONTENTS～

FOREWORD AND ACKNOWLEDGEMENTS

Kate Fowle
EXECUTIVE DIRECTOR

Renaud Proch
DEPUTY DIRECTOR

As an organization at the forefront of promoting curatorial discourse, Independent Curators International (ICI) has, over the past thirty-six years, pushed the boundaries of exhibition-making, and supported new forms of curatorial practice. So, when artist Harrell Fletcher and curator Jens Hoffmann approached ICI with their exhibition idea, the collaboration made perfect sense. *People's Biennial* was to be a survey of artists in five American communities far from the major art centers; it was to be conceived, researched, and assembled by working together in each of these regions with an art institution that would in turn host the exhibition tour. ICI was uniquely positioned to take on this project, as the organization had developed a strong network of institutions over the years, as well as a deep understanding of curatorial collaborations throughout the United States. Moreover, *People's Biennial* represented an opportunity for ICI to test a new exhibition model by sending the co-curators to the five participating venues in the early stages of research. Even before the artists or artworks had been selected, the exhibition process began collaboratively, with touring people rather than objects. From the onset, each venue was involved as an active partner, contributing to and shaping the exhibition's development.

A snapshot of American creativity beyond the major art centers of, say, New York or Los Angeles, *People's Biennial* presents the kind of talent that exists regardless of the infrastructure available in the art world, from MFA programs to commercial galleries. Harrell, Jens, and ICI dedicated a year to research and travel, working together with all five venues to meet with artists through open calls, visits to local libraries, art therapy centers, alleyways, storefronts, and other unexpected places for artistic production. The research was extensively documented and shared with the public through ICI's *People's Biennial* blog, which recognized the need for transparency when assembling such a unique project. An experimental, and without a doubt controversial, idea, this exhibition is not intended to supplant existing art-world systems, but rather to diversify these and energize other, community-based structures across the United States. In trying out new ways of conceiving a traveling exhibition, ICI embraced the perspective of the curators, while preparing for the unknown. What happened along the way has been remarkable and enlightening.

Local artists enthusiastically responded to announcements made through newspapers, radio, email blasts, and word of mouth, to attend the various forums held for them to show their work, as well as to the series of presentations and roundtable conversations with Harrell and Jens. For the curators, this was an opportunity to meet not only the artists interested in taking part, but the individuals that would form the future audience for *People's Biennial*. Such a process constantly asked the curators to consider, defend, and ultimately refine this itinerant exhibition with a stronger understanding of context.

This publication offers several entry points into some of the impact that the project already has had, and it begins to uncover the exhibition's nature as a catalyst for

conversation about curatorial and artistic practice. It reveals firstly a collaborative exercise between an artist and a curator, and, secondly, a collaboration between this duo and their counterparts in all five partnering venues. It also shows the project's ability to generate another kind of discussion: one among artists who took the various open calls and public panels as a chance to meet, to claim their local art institutions as their own, to begin conversations about their practice, and to compare works, techniques, and ideas.

As this publication goes to press and the exhibition continues its tour, these relationships built among artists remain alive and are strengthened every time the show opens in a new city, bringing people together again for the occasion. A traveling exhibition that is always partly at home, *People's Biennial* is an opportunity for the artists to see their work in a different light, and together with other artists' works from states far away. In an effort to also reinforce the connections among the larger curatorial team, a panel discussion in Chicago brought together the curators from the five distinct art institutions. As some met for the first time, they shared their experiences of the process, and investigated the potential to expand this collaborative network of institutions, artists, and curators on a local, and national level.

As ICI continues to open up lines of communication and collaboration regionally and transnationally, the impact of this project is a reminder of the value of connecting curators and their research to a variety of artists, and to support a wide array of practice.

The exhibition and publication have been made possible through the dedication of many individuals, and on behalf of ICI, we would like to thank, first and foremost, Harrell and Jens, whose conception of and commitment to this project have resulted in an illuminating venture for ICI. We would also like to thank the artists in *People's Biennial*, who not only shared their work with ICI, the curators, and their local com-

munities, but who also parted with their work for the exhibition, so that more could experience their talents. Thanks to the presenting venues' curators: Matthew Callinan, Campus Exhibitions Coordinator, Haverford College, Pennsylvania; Cassandra Coblentz, Associate Curator, Scottsdale Museum of Contemporary Art, Arizona; Kristan Kennedy, Visual Art Curator, Portland Institute for Contemporary Art, Oregon; Steven Matijcio, Curator of Contemporary Art, Southeastern Center for Contemporary Art, North Carolina; and Mary Maxon, Curator of Exhibits, the Dahl Arts Center, South Dakota, who all trusted in and threw themselves into the project and contributed their insight to this publication.

We would also like to thank ICI's staff, especially Frances Wu Giarratano, Exhibitions Manager; Alaina Feldman, Exhibitions Assistant; Susan Hapgood, former Director of Exhibitions; ICI's former exhibitions interns Greg Barton and Anna Follo, and current exhibitions intern Marika Elsebeth Kielland. ICI extends its appreciation to Jon Sueda, who not only designed this publication, but also the graphic identity of the exhibition, and to copy editors Diego Hadis and Lindsey Westbrook.

Crucial to the development of this exhibition and publication are generous awards and funds from the Elizabeth Firestone Graham Foundation, The Andy Warhol Foundation for the Visual Arts, The Horace W. Goldsmith Foundation, The Cowles Charitable Trust, and ICI Benefactors Barbara and John Robinson.

Finally, we extend our warmest appreciation to the ICI Board of Trustees for their support and enthusiasm.

There were many more people involved in the process who helped make the *People's Biennial* events, open calls, and exhibition a communal success, and a full list of acknowledgments, as well as the curators' personal thanks, can be found on page 130.

VOICES OF AMERICA

Jens Hoffmann

People's Biennial isn't what one expects when one hears the word "biennial." It is not like the Whitney Biennial, presenting a survey of the most "important" art made recently in the United States. And it is also entirely unlike the one in Venice, which is the oldest and largest of the type, showcasing a sprawling overview of contemporary art from around the world, plus dozens of solo exhibitions mounted by individual countries to herald their most renowned and professionally successful artists. *People's Biennial* has very different goals and intentions, and, although it is certainly ambitious in its own way, a much looser structure. The first manifestation of *People's Biennial* is a large-scale traveling group exhibition, but it may well take on very different formats as it develops over the years to come.

The inaugural *People's Biennial* is presented at five art institutions in the United States: Cantor Fitzgerald Gallery at Haverford College in Pennsylvania; the Scottsdale Museum of Contemporary Art in Arizona; the Southeastern Center for Contemporary Art in Winston-Salem, North Carolina; the Dahl Arts Center in Rapid City, South Dakota; and the Portland Institute for Contemporary Art in Oregon. The venues were selected from an open call made by Independent Curators International to their network of art institutions throughout the country. They are geographically spread out, and are also not considered "mainstream" art centers, which was for us a crucial criterion. The show consists of contemporary works by six to eight artists from each of the five institutions' local communities. Harrell Fletcher and I visited each community for up to a week, conducted research, lectured, held roundtable

discussions with local artists, and finally selected the artists and works to be featured.

For us, *People's Biennial* responds to several frustrations with the homogeneity and insular aspects of other biennials today, as well as the spectacular nature of many of these global exhibitions. Most biennials in the United States focus myopically on art from just a few cities—usually New York and Los Angeles, and sometimes Chicago or San Francisco. An even larger problem is the art world's ever-increasing self-isolation and exclusivity, which has turned the spaces where art is produced and exhibited into privileged havens detached from the ordinary realities of everyday life. *People's Biennial* promoted an alternative selection process and devoted itself exclusively to work by artists who have never had significant exposure. The exhibition focused on creative talent that did not subscribe to the conventional structures we are used to operating in, allowing us to discover work that is more immediate, spontaneous, even vulnerable, and offering a potential model for more community-based, grassroots exhibitions. In appearing grassroots or amateur, *People's Biennial* calls explicit attention to how most so-called professional art is merely art that conforms to a set of conventions that most of us have accepted and internalized. Our biennial uses typical display techniques, but with a subversive intent: to set up a feeling of familiarity in the viewer that is then shattered by the unorthodox artworks on view. The goal is to present art as it is, and not as it so often seems in other biennials: distant, conceited, calculated.

The title *People's Biennial* embodies a number of references. It is in part an homage to Howard Zinn's classic book *A People's History of the United States* (1980), which speaks about the history of this country from the perspective of the disenfranchised, the discriminated against, the excluded, the marginalized. It also refers to Group Material's 1981 exhibition *People's Choice*, which featured art and non-art objects contributed by residents living on the same block as Group Material's storefront space on Thirteenth Street between Second and Third Avenues in New York.

The idea for this project originated in a conversation I had with Fletcher in 2008, after the opening of the exhibition *Amateurs* at the CCA Wattis Institute for Contemporary Arts in San Francisco. The show, curated by Ralph Rugoff, explored the idea of amateurism in contemporary art. The works in that show were made by mostly established and well-known artists (one of whom was Fletcher) working in collaboration with so-called amateurs. For this biennial, Fletcher and I pushed the concept further, seeking out artists who are entirely outside established art circles. Fletcher is an artist who frequently collaborates with others—both artists and "non-artists"—and presents their works

in the format of uniquely created exhibitions. I operate from the position of a curator who views exhibition-making and curating as not just academic, but creative and artistic. Both of us are deeply motivated by a wish to diversify the art world, both in terms of exhibition models (by introducing unorthodox curatorial processes) and in terms of displaying artworks that are outside the mainstream.

The first iteration of *People's Biennial* surpassed my expectations. I am gratified by the high caliber of the artists and artworks we discovered, which reinforces what we instinctively knew, and I also find myself deeply affected by my new understanding of the mechanisms of the art world, and the cultural and political landscape of the United States. The places we visited could not have been more different from one another, and each had its unique set of complexities. Our travels offered a fascinating glimpse into the diversity of creative production in a number of regions usually dismissed as the cultural periphery. We were touched by its realness and authenticity, which are very rare in the art world.

In response to the amazing artists and work we selected, and as an extension of *People's Biennial*, we have established the People's Gallery, a one-year-long series of solo shows in a storefront space in the Mission District of San Francisco. Six artists from the biennial will present their work there, allowing for an opportunity to go more in-depth and show work that couldn't fit in the traveling exhibition.

People's Biennial is a unique collaboration between an artist and an exhibition-maker who share a similarly critical, yet also optimistic, outlook on the art world. It is a summary, a condensation, of many of our thoughts around art and exhibition-making, and hopefully the start of many more exhibition initiatives that will, in various ways, highlight artworks made by the *people*.

PEOPLE TALKING

Harrell Fletcher and Jens Hoffmann

Harrell Fletcher (HF): I'm reading Howard Zinn's *A People's History of the United States* right now. I've always meant to read it, but I kept putting it off, wanting to save it for later, knowing that it would be really amazing (and depressing). I know that for you it's been a strong influence on *People's Biennial*. Can you describe the parallels between our project and Zinn's?

Jens Hoffmann (JH): I have always been fascinated by history and how it is constructed. *A People's History of the United States* proposes an alternative view of American history, one that is written by the people, not by the political or economic elites. Zinn speaks about the United States as having a history of popular struggle for human rights marked by a fight against oppression, slavery, militarism, racism, war, and economic exploitation, which are condoned by the ruling class. I think what connects our project with Zinn's book is that we are trying to look at artists and places that are on the periphery of the art world—the marginalized and excluded.

HF: The art world tends to overlook artists who aren't showing in commercial galleries in New York or Los Angeles (and the handful of other cities that are part of the mainstream art system). With *People's Biennial* we are offering both an example of a wider view of art activities in the United States, and, to some extent, a critique of the existing commercial art structure. Challenging art-world conventions is something that I've always been interested in, and it's one of the reasons I chose to live in Portland, Oregon. You are much more a part of the international art scene than I am, so it is interesting to me that you

are also compelled to address these issues.

JH: My main interest is in pointing out the richness and diversity of creative production in the United States. I am of course interested in the idea of challenging the art world, and society at large, but ultimately for me our undertaking is about opening up to artists who are not known, who make great work that never gets seen because they are not part of the official art system.

I have to challenge myself as a curator to think about art and exhibition-making in ways that are rarely thought about. This is where I get a lot of inspiration. What we see in major galleries and museums is one small portion of the work that is out there. I mostly attribute this narrow outlook to prevalent art-market forces that by and large dominate the production of art in the United States. It is commodity production, and everyone is in the business of creating market value for art and artists. Even you and I do it every day. I think the two of us have come to a point in our respective careers where we feel like undertaking projects that use past accomplishments to bring attention to deserving artists. I think it is a very privileged position, one that I take seriously and am thankful for. While I work for many mainstream museums, write for art magazines, and exhibit well-known artists, I also live in San Francisco, run a gallery based out of an art college, and spend a lot of time teaching; and I wouldn't have it any other way.

HF: I hear you on the need to open up the art world to a wider set of possibilities. I've always been a bit shocked at how conservative and market-driven the art world can be, in the gallery and museum system and also in academic programs. I have a background in small-scale agriculture, and I often relate art to farming. In many ways I see a dominant part of the art world operating like big agro-business, with its emphasis on monocrops, global trade, and standardization. I'm much more interested in small systems that prioritize local production and distribution, diversity of crops, and sustainable practices. I've tried to apply some of those ideas to my own life and art practice, although it has been tricky and has not always been successful.

To me, *People's Biennial* is an attempt to work on some of these same issues. We have selected a diverse set of artists and works, and we have created a format in which the work is shown both locally and nationally. Through the increased exposure this brings, we are hoping to help develop some of the artists' careers and diversify the system we critique. Maybe we should discuss a couple of specific examples?

JH: It is hard to pick any one out in particular, but if pressed I would probably begin with our experiences in South Dakota. That was where I felt farthest away from major art centers: in terms of geography, aesthetics, and social

context. Seeing firsthand the unresolved politics between Native Americans and Anglo-Americans added a lot to our experience. Coming as an outsider into such a complex situation as the Pine Ridge Reservation was very thought-provoking. The art we saw made by Native Americans was extraordinary; it affected me strongly. And talking to the artists and hearing their families' stories was a history lesson.

A lot of the other work we saw in Rapid City, South Dakota, also spoke to me on a profound level, moving me beyond my ideas around our exhibition and opening up a lot of new thoughts. There is certainly a strong sense of independence there: artists making work they want to make, regardless of prevalent aesthetics in the art market or in museums. There were numerous artists in Rapid City who we considered for the exhibition, but did not have space to include.

HF: Yes, the visit to South Dakota was very compelling for me, too. It was the first place where we tried out the totally open call to artists and then had three different venues where people could come and show us their art: two on the Pine Ridge Reservation and one (very well-attended event) at the Dahl Arts Center in Rapid City. The open calls had been widely advertised and we ended up meeting more than 150 artists. There had been some trepidation about the open process on the part of the people we were working with, from anticipation of a low response to fear of an overly broad representation when it became clear the attendance was going to be very high. That was what we wanted, and we saw work that we wouldn't have run across any other way.

I also think it's worth making an interesting side note here: At the first open call on the reservation, there happened to be a set of really amazing paintings on the walls of the room we were using, a community room at a Catholic church. We asked about them, and learned that they had been done almost 30 years ago by Jake Herman, who was Sioux and had lived on the reservation, but was now deceased. The paintings depict various Sioux legends, and are really amazing. They were familiar and meaningful to the people of that community, who had grown up and lived with them, but they had never been seen outside of that context. We decided to include a selection of them and were fortunate to be loaned six of the paintings for *People's Biennial*. Herman is the only non-living artist in the exhibition, an exception we decided to make because his work is so extraordinary. There are several other examples of people we included who were outside our initial guidelines or expectations.

JH: From the onset, we kept our guidelines and expectations very loose, which at times was of concern to the curators on the ground charged with communicating them to artists or the press. Was it outsider art? Amateur art?

Art by self-taught artists? We never wanted to define it exactly, so as not to confine ourselves to categories, and I think that contributed to giving the exhibition such energy and such a subversive character.

The show has a fantastic range of practices included, such as rodeo photographs taken in the 1970s, models of entire cities made of clay, mutant piñatas, sculptures made of computer and cell phone circuit boards, surrealist biology videos, anatomical drawings of human accidents, twenty-five years of drawings on a series of old Finnish pocket calendars, heavy-metal cartoon animations, wood paintings of African-American leaders, paintings done by break dancing on a canvas, a video reenacting the movie *The Poseidon Adventure*, photographs of National Guard maneuvers, and comic books about the history of Native Americans in South Dakota. It was all really astounding.

It was very difficult to make our choices. In the end, it was about creating the most diverse possible selection of works, with the goals of giving the audience some kind of overview of what is being made out there, showing very different and varied types of works, and creating an extremely interesting overall exhibition experience. One project from Portland really impressed me: Judge Evans's community-court art program, which gives people convicted of small crimes the option to pay a fine, go to rehab, do community work, or make an artwork for display at the courthouse. I love what he has brought together, and how art can appear in totally unexpected circumstances and contexts. Or the artist from Arizona, Andrea Sweet, who created an incredible history display in the public library as part of a self-initiated education program. She filled a vitrine with objects and documents of sadly common racist propaganda in the United States, from Reconstruction on up to the Civil Rights movement.

But I would like to go back to your earlier question, about focusing on an overlooked aspect of American creativity while critiquing a mainstream art world we are part of. It was interesting to me that some people learning about the project have found a contradiction in this, and we have encountered others on our travels who question our motives as being more self-promotional than issued from a general interest.

HF: Yes, that was strange. Not that there's anything wrong with taking credit for the work that you do (regardless of what that work is—making art, curating shows, etcetera). Attracting attention to ourselves truly wasn't our motivation. However, I think that the confusion, once again, stemmed from assumptions and conditions that permeate the art world. For some reason, it is often viewed with suspicion when an artist, like myself, blurs into the role of a curator, or vice versa. I can't think of any reason why that should be a bad thing, though. It's not like a lawyer slipping into the role of a surgeon, or a

flight attendant deciding to fly a plane all of a sudden with no pilot's training. No one will get hurt if an artist curates a show.

I see my practice in broad terms, and I define art equally broadly. Basically, anything goes. I think the great thing about working in the arts is that you have flexibility and can do what you want as you want to do it. While others may need to define a hobby, as an artist (or, in your case, as a curator), if I become interested in something, I can incorporate it into my professional practice.

So, coming back to *People's Biennial*, and our roles in it, I don't believe there is a contradiction in taking ownership of this project that is genuinely intended to provide a platform for others. Really, it would be much weirder if we did this anonymously. Then no one would know who to attribute the decisions to, regardless of how he or she felt about them. In other words, if you don't like the show, you can blame us. In film or theater, there is never a problem giving credit to the director even if that person is working with amateur actors or production people. Of course, everyone else gets credit, too, and we have done that with this project as well. I think that the desire for clear boundaries and categories in the art world is another market-based concern. It is a way to keep the solo "artist-genius" paradigm alive and well. But deep down, no one really wants to operate only in narrowly defined ways. It's just not healthy or interesting.

JH: I remember being met with some skepticism at an event in Scottsdale, Arizona. At the time, I wondered, "Has a certain academic training taught us to think critically, and not to just take things as they come? And has the influence of critical theory on our way of thinking become pure suspicion or even paranoia of anything that is different, new, or challenging?" To me, the effect is just as negative as that of the market forces we spoke about before.

It was interesting to see how people in the various cities responded differently to *People's Biennial*. In Portland and Scottsdale, where there are more connections to the mainstream art world, audiences were far more critical—specifically, they were skeptical of what constituted an artist or artwork. I had the feeling that some artists in the audience felt that they were being left behind again. I say "again" because they already feel overlooked by other biennials. They are frustrated that the Whitney Biennial for example rarely pays attention to their cities, and that *People's Biennial*, while focusing on their regions, may not give them recognition. I also remember someone asking me why we are not bringing the show to New York or Los Angeles. It might seem like an interesting idea, since the artists in our exhibition would get exposure in those major art centers, but for me it reinforced the problem of how everything in

the art world is so focused on those two cities. With this publication, the artists' work can be shared on a national, or even international, level, without putting emphasis on the art-world centers.

HF: Some people find it ironic that we worked with a New York–based arts organization to create a project that is all about art produced outside the New York–centric art world. To me, it is interesting to employ existing resources to do unorthodox projects. Independent Curators International (ICI) has a lot of experience developing and distributing contemporary art exhibitions, and they easily adapted their working methods to make *People's Biennial* run smoothly. There really isn't any other organization like it in the country.

JH: It is a strong testament to ICI's ambitions and the scope of their thinking that they ran with us on this rather unorthodox project.

As a final topic of conversation I want to bring up our working relationship. It is a full collaboration in which we both have the exact same tasks and responsibilities. We share the same overall ideas about why we are doing this project, as it supports the more abstract value we both place on seeking out the overlooked, and fostering diverse thought via art and exhibitions. Yet there is something different in our interests. Can you articulate what that difference is?

HF: When we examine our past work—which we have done a lot in the joint lectures we've presented at each of the cities we visited—some interesting intersections and also some differences have become evident. We both work in unorthodox ways, and show work of various kinds that has had limited exposure. To me, one of the most interesting aspects of your past projects is how you have worked with very successful artists, but have asked them to show or make work that is different from what they are typically known for. At LACE in Los Angeles, with *A Walk to Remember*, you had John Baldessari and Paul McCarthy create walking tours that were related to their lives and interests. At the ICA in London, you curated *Surprise Surprise*, an entire show of works by big-name artists that were anomalous relative to the artists' signature styles.

My work has been more about collaborating with and promoting non-artists, sometimes exhibiting the results in established art venues. Overall, though, specific definitions are difficult because neither of us has a fixed mode of operating. I think this is a factor that has made it very easy for us to collaborate.

A new development in the project has been our plan to open a temporary gallery in San Francisco to give solo shows to some of the artists in *People's Biennial*. We will start with an exhibition of Bob Newland's rodeo photographs. Do you want to talk about the reasons for opening the gallery, and also maybe

say something about your affinity for these photos? Newland's work, in my opinion, is an example of vernacular subject matter that is very broadly engaging, largely because it is so aesthetically compelling—a dynamic that characterizes a lot of the work in the exhibition.

JH: The idea for the gallery is based on my desire to work more in depth with a few of the artists from *People's Biennial*. San Francisco in many ways embodies my whole philosophy of art and exhibition-making. It is a very sophisticated city with a long history of progressive and unorthodox thinking, and it is intellectually and artistically very stimulating. It seems more encouraging of experimentation and radical ideas than other cities. Yet it is also on the periphery, and not just in the art-world sense. I always jokingly call it the edge of the avant-garde.

The gallery's first year of programming includes five solo shows and one group show, all featuring *People's Biennial* participants. It is directed by Jana Blankenship, who has collaborated with me on a number of projects. And yes, Bob Newland's photographs of rodeos in South Dakota, shot mostly in the 1970s and 1980s, are incredible. Their attraction for me might be related to the fact that I am a foreigner, but they are formally so sophisticated that everyone I show them to is captivated. They depict something very raw and untamed, yet also culturally quite complex. For me they are a great example of the kind of work I hoped to encounter as we set out to begin our research for *People's Biennial*.

Let me ask you one last question. Now that the tour has started, and the exhibition opened in Portland and Rapid City, what was your reaction to seeing the show all come together?

HF: It was really great to experience the artists' reactions to seeing their work exhibited. In Portland, we invited the public to a walk-through with me and all of the local artists. We had a good turnout, and I think it was a wonderful opportunity for the artists to talk about their experiences with the process and their feelings about their work. The fact that local artists will be represented in each venue is a key part of this project, and something that makes it very different from most traveling group shows.

JH: Yes, I noticed how in Portland and Rapid City, there was a sense of ownership of the exhibition because of the participation of local artists. They all came to the openings, and I enjoyed the chance to talk to them about the show and also about new work they were making. I think that the selection of artworks is quite eclectic, and even when packed into a somewhat smaller space, the works create a refreshing and energizing experience.

⪽PORTLAND, OREGON⪼

My office had become a sort of detective agency. Rebecca Steele, my curatorial assistant, was helping to track down one of the *People's Biennial* artists, Warren Hatch, and was on the phone with the "worm lady," from whom Hatch purchases his worms. We had set up shop in an old, abandoned high school, and upstairs, in an empty library, we would install *People's Biennial,* an exhibition that was still in process, building as the curators traveled from city to city. We could only imagine it finally coming together, and finding Warren Hatch was the missing link.

Hatch was one of the artists selected by the curators to represent Portland in their exhibition experiment. The artist was busy conducting experiments of his own, building out backyard environments for local organisms—spiders and bees and worms—to live in and thrive. The curators did not meet the artist on their visit to Portland, but rather found his work at the Multnomah County Library, one of the many libraries around the country where Hatch distributes his videos for free. The PO box address on the DVD suggested that Hatch might be closer to us than we had imagined. During the exhibition's research-and-development stage, Hatch seemed like an elusive myth. Trace evidence of his life could be found on obscure science Web sites and in anecdotal stories of his tenure as a substitute teacher, but little else was known.

But at last, Rebecca had a lead: The "worm lady" had come through with an e-mail address. I sent off a note to Hatch outlining our interest in showing his work, and it was then that the conversation began. It turned out that Hatch lived close to the high school, and Harrell Fletcher and I could meet with him in a few weeks. In a lively discussion about the nature of his work, Fletcher and Hatch connected over a series of rich ideas and vibrant images that excited them both, and that begged for display and dissemination.

The curators' experiment in exhibition-making became as much about our obsessions with the constantly shifting definitions, structures, and values attributed to art as it was about the artists and their work. While the exhibition was on view, it was widely attended and constantly debated. It posed more questions than it answered, and because of that it was a success. In each piece, in each artist's story, there is a lesson. Like Rebecca and me, the curators were detectives following clues that revealed great artists and great work. Like Hatch, the curators turned a magnifying lens on five different local environments in the form of five diverse cities. As institutions, curators, artists, and audiences, we need to look and relook, and redefine what art is while recontextualizing its meaning. What is worthy of the title "art"? Who is worthy of the title "artist"? Certainly, every piece in this show, certainly, everyone included in it, and most definitely Warren Hatch.

KRISTAN KENNEDY
Visual Art Curator, Portland Institute for Contemporary Art

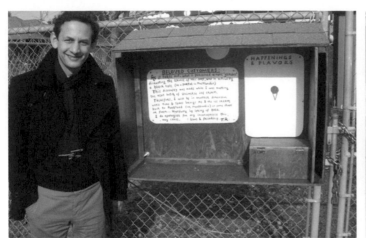

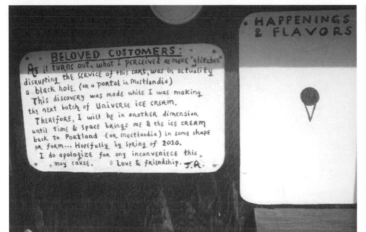

Text visible in image 6:

• HAPPENINGS & FLAVORS

• BELOVED CUSTOMERS:
As it turns out, what I perceived as mere "glitches" disrupting the service of this cart, was in actuality a black hole. (or a portal to Mostlandia)
This discovery was made while I was making the next batch of Universe Ice Cream.
Therefore, I will be in another dimension until time & space brings me & the ice cream back to Portland (or Mostlandia) in some shape or form... Hopefully by spring of 2010.
I do apologize for any inconveniece this may cause. ♥ Love & Friendship. J.A.

ALLY DROZD

with Judge Evans and the Portland Community Court

I began working with the Portland Community Court in the spring of 2010, after hearing about a judge who assigned people to make a work of art as atonement for their offense. Judge Evans, who has presided over the court since 2004, implemented an art program for offenders to create a work of art that is relevant to the offense that landed them in court, their experience with the justice system, or to their community of Portland. The artwork, displayed in the court for a year, counts as their service to the community, earning them a dismissal or a sentence of discharge in their case.

The majority of people whose cases are heard by the court struggle with addiction, mental illness, or both. Many are also homeless. The court works hard to connect people with resources for housing, addiction treatment, or mental-health counseling. As one of the main objectives of the court is to help people with the issues that may be contributing to their unlawful behavior, I find it radical and exciting that the creation of art is being recognized and validated as a productive means to achieve that goal.

For *People's Biennial,* I worked with Judge Evans and his staff to curate a selection of works from the courtroom, which in past years has become an unexpected art gallery. I am thrilled for the opportunity to highlight not only the effort of Judge Evans and his staff, but also the artists, whose works helped them to notice, investigate, understand, and come to terms with themselves and the world around them.

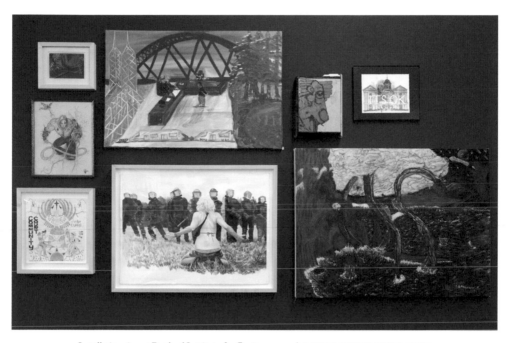

Installation view at Portland Institute for Contemporary Art. TOP TO BOTTOM, LEFT TO RIGHT:
Rueben Lee Torres, *Untitled,* 2010; Daniel Koszorus, *Self-Portrait in the Future,* 2009;
Donovan Brown, *Untitled,* 2007; Darig Herandez-Cruz, *Untitled,* 2010; CJ Randall, *March 20,* 2010; Zack Hamilton,
Name face. Game. Game., 2010; Alex Walter, *Broken Arc,* 2010; Cameron Hawkey, *It's a Dismissible Case,* 2010

∾WARREN HATCH∾

Warren Hatch is a natural scientist, educator, documentary filmmaker, and fellow of the Linnean Society of London. Hatch began using the Eschenbach illuminated microscope in classrooms in South Central Los Angeles in the late 1980s to fully engage students in the minute and often overlooked beauties and intricacies in the surrounding natural world consisting of the plants and insects inhabiting the school's parking lot or playground. For a time, Hatch transported twenty-four of the Eschenbach microscopes in his backpack, using public transportation, to the schools in which he taught. Hatch began to photograph and film these same tiny subjects, and edited the videos into natural-science guessing games like *What's That Through the Microscope?* In 1995, Hatch moved to Portland, Oregon, where he purchased a house and slowly transformed his backyard into small aquatic habitats with about twenty-four "mini-ponds" that support a diverse offering of local amphibians, insects, and plants. Hatch uses these environments to study, film, and narrate such endeavors as *Green Beauty Alive Through a Microscope* (2003); *In One Yard: Views Through a Microscope and Up Close* (2006); *A Frog's Life: Seen and Heard* (2008); *Bees and Wasps: An Appreciation* (2010). He believes "some people think that it is necessary to travel hundreds of miles, burning up many gallons of petroleum, to get to a tropical rainforest, to Yellowstone National Park, or to Hawaii, in order to experience great natural beauty. This is a false notion, though billions of dollars are spent each year by airline companies and tourist agencies to promote it. I have experienced the greatest beauties in my own yard, beauties which are only revealed through magnification and illumination."

REBECCA STEELE

*Curatorial Assistant, Portland Institute
for Contemporary Art*

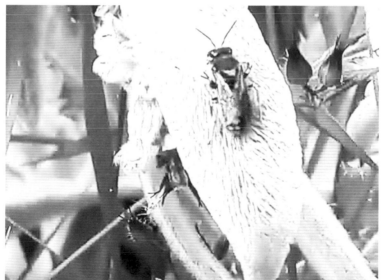

Bees and Wasps: An Appreciation, 2010 (video stills)

~ELLEN LESPERANCE~

My work stems from archival activist footage. In this footage, I seek out women involved in direct-action campaigns who are wearing sweaters that reflect their ideological intentions in some way. I then go about creating a knitting pattern for these found sweaters as carefully as possible: imagining the weight of the yarn, choosing era-specific styling, deciding which colors would best approximate the values in a black-and-white photo, and sometimes imagining a sweater in its entirety when it is only partially seen. I paint my patterns in gouache on paper that I grid to reflect the appropriate yarn gauge, which provides me with the guide to re-create each sweater.

I make this work in order to memorialize the glory of effective resistance, in an effort to ensure that these moments do not vanish from popular memory, so that they can reach new audiences to inspire. For example, a site of continual research and awe for me is the all-women, anti-nuke Peace Camp at the Greenham Common U.S. airbase in Berkshire, England, which was held for nineteen years in the 1980s and '90s. I have a particular interest in assigning valor to women like Rachel Corrie and Beth "Horehound" O'Brien, young women who have sacrificed their lives fighting the good fight. I also like the idea that, through the re-creation of a Greenham sweater, I might inspire a new "wearer" to future fights.

She Stormed the Compound Singing: "Old and Strong, She Goes On and On, On and On,
You Can't Kill the Spirit, She Is Like a Mountain," 2009,
gouache and graphite on paper, 23 x 29 ½ in. (58.4 x 74.9 cm)

∾DENNIS NEWELL∾

Dennis Newell is an artist working with Lego building sets, and a lighting enthusiast, residing in Portland, Oregon. Newell thinks and works in component systems where a whole is comprised of the orderly rearrangement of parts. He creates hybrid, customized spaceships and dramatic scenarios from discontinued Lego kits, something he has been doing since he was a child. To the artist, rebuilding things anew from existing parts is a way of modeling one's own ideas from a suggested pattern: It's about tweaking and reformatting. He orders components by color and contour, and learns by taking apart and putting together altered constructions. This approach is something that Newell has applied to other mediums, as in his customized, rebuilt 1963 Chevy Impala.

REBECCA STEELE
*Curatorial Assistant, Portland Institute
for Contemporary Art*

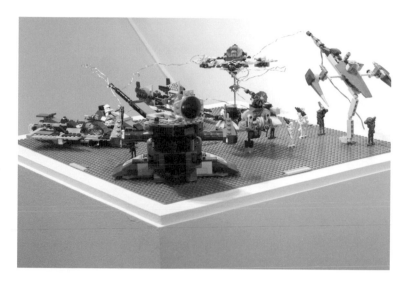

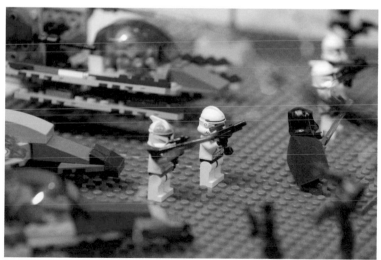

Lego Battle with Droids and Clones, 2010
(installation views, detail on bottom)

∾DAVID ROSENAK∾

I'm wired to paint. What else would I do? I have no idea.

Rather than casting about for something new, I'm always trying to find the truest, most vivid expression of an impulse that was in me from the start. So I paint more or less the same thing, over and over, in the hope of getting a better result. I'm trying to get at something.

It's hard to say, but I've come to think of myself as trying to evoke the feeling of being alive and in the world, just letting everything make an impression. That may or may not be right, but if it doesn't interfere with the viewer's experience, it'll do.

I've been sticking closer and closer to home in my search for material. In theory, I could set the paintings anywhere, but in practice I've learned that the more I've experienced a subject, the more I have to draw from when I compose an image. When a subject has grabbed my attention, I have commonly spent months or years just looking at it before I started work in the studio. It has then been useful to revisit the object freely in the months or years it has taken to complete the painting. So limiting my range to material close to me has been a consequence of developing my practice rather than an end in itself.

OK, I suppose I could clean my house, but...

Untitled, 1998, 2008, oil on plywood, 16 x 27 ⅞ in. (40.6 x 70.9 cm)

~JJ ROSS~

My art comes from my heart. I want to be a good artist. It makes me feel good. I'm happy when I draw.

My first drawings were of Walt Disney figures and the Power Rangers. Star Wars and Indiana Jones were next. I would like to be a superhero. Batman has fun. Good and evil are both in the world. Movies and art remind people of what goes on in the world. People can see that heroes are good and villains are evil.

I know I'm different. I want to be stronger. When I draw, I am a superhero. I save the girls. I protect my friends. I protect my family.

LEFT TO RIGHT: *Tossing the Fish,* 2010; *Dragon King,* 2010,
both marker and pencil on paper, 11 x 8 ½ in. (27.9 x 21.6 cm) each

~RUDY SPEERSCHNEIDER~

I dream about orange paint, imaginary lands, and making ice cream...I feel a tug at the gut, a buzz in the head, a rousing energy pouring from the heart, all over the place, I see stars, I must live...The dream has to come alive, at once, or I die, so the metamorphosis begins—consuming, passionate, like magic, madness, and supernatural powers, it turns, twists, and infuses the sense of wonder into the palpable state of things. How can I, the idea, and the process stay true to ourselves, together and sincere, during the staggering transition from the safety of the imagination to the rigors of reality? Can we withstand the weight of responsibility, the heat of emotions, the burden of bureaucracies? Will we melt?

I go, I do, I am, I rip apart reality to make room for the new dream. And underneath, within, and all around, I find other ideas (similar and different), and meet other people's imaginations (wild and tame), and run into other realities (light and dark), and they mix and mingle, and there's love, excitement, pain and fear. But this only means something extraordinary is happening, right? Something more than what the original dream was. New things are noticed, not yet imagined, never experienced, beyond the imagination. Endless possibilities, within reach, suddenly, reality, serendipity, Mostlandia, like a scoop of ice cream, it takes on a life of its own. Patience. It's not my dream anymore, it's everybody's, and everything. And this process, this experience, these revelations, are much more important, much more fulfilling, than any artworks made, new worlds discovered, or ice cream cones sold. So, I keep dreaming...

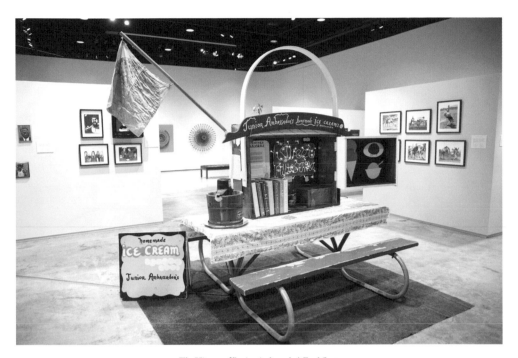

The History of Junior Ambassador's Food Cart:
A Mostlandian Venture, 2007–2009 (installation view)

ᰍ RAPID CITY, SOUTH DAKOTA ᰒ

In January 2009, the Dahl Arts Center opened the doors to a newly expanded facility. While still tiny in comparison to art centers in more urban settings across America, it was a big upgrade for contemporary arts in South Dakota. The expanded, secure, and climate-controlled gallery spaces definitely caused a shift in the conversations about what the Rapid City Arts Council could provide in the effort to fulfill its mission of "bringing art and people together to enrich lives and strengthen community."

The *People's Biennial* project seemed perfectly designed to address this part of our mission. It also looked like the kind of project that could help us build relationships with local talents that were not, and may never have been, involved with the Dahl Arts Center without some specific encouragement.

So there we were, the fledgling arts center, standing at the edge of what seemed like an ocean of new opportunities. *People's Biennial* was like dipping a toe into the water, finding it neither too hot nor too cold, but perhaps a little scary—though not scary enough to keep us from jumping in with great enthusiasm. And this is what the staff, volunteers, and a myriad of regional artists did.

While the goal of the project was clear, the parameters of what the curators were looking for seemed purposefully vague. It proved to be both a challenge and a unique opportunity to communicate with potential participants what no one, including the curators, knew: What kind of art were they interested in? It seemed they were going to consider anything and everything, and with that in mind, marketing efforts were tremendously encouraging and totally inclusive.

In order to reach out to as many participants as possible, and to give the curators a real sense of the everyday challenges and opportunities that are unique to our area, travel was in order. In this land where we measure rain in hundredths of an inch, distance in hours, and population by square miles rather than by square feet, we needed to get them out on the road as much as possible during the few days of their stay—experiencing the reality of the Black Hills and Pine Ridge and other parts of our community in the only way possible: by going to them.

With open-call events at the Sacred Heart Church, Pine Ridge; Oglala Lakota College, Kyle; and the Dahl Arts Center, Rapid City, we also asked our community to come to us. And the community did show up! During such a short visit to our area, the curators spoke with over 150 people who were interested in participating in their project.

We are very proud of the artists in our community, not only for the vibrancy that they contribute to life in the Black Hills, but also for the enthusiasm and the courage they showed in response to this request to see their work. The Dahl is grateful to all of the artists who took the time to participate in this project. We congratulate all of them.

MARY MAXON
Curator of Exhibits, The Dahl Arts Center

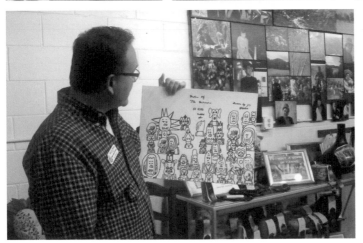

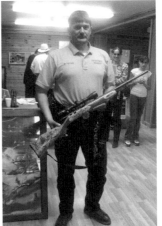

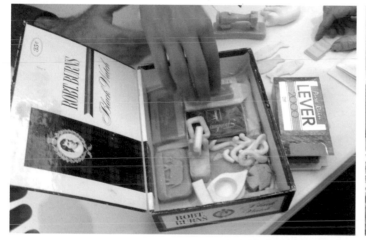

⟶CALEB BELDEN⟵

This selection of works represents most of my best drawings. They are not exactly my own original ideas, as some of them have been inspired by television shows, bands, and movies. You may recognize a number of these subjects if you know a lot about the media. It is very fun for me to draw people—the details and shading are what I enjoy most about drawing. In these works, I have used special pens, colored pencils, regular pencils, and markers. For most of them, I start out with a regular pencil just in case I mess up, so I can just go back and erase anything. Once I am done with that part of the drawing, I trace over it with a pen. Then I erase the pencil marks and start with the shading and small details. For some of these drawings, I wanted to be careful not to mess up a single detail. With the pen drawings, I had to use a black marker for some of the big details. I hope you enjoy looking at my drawings.

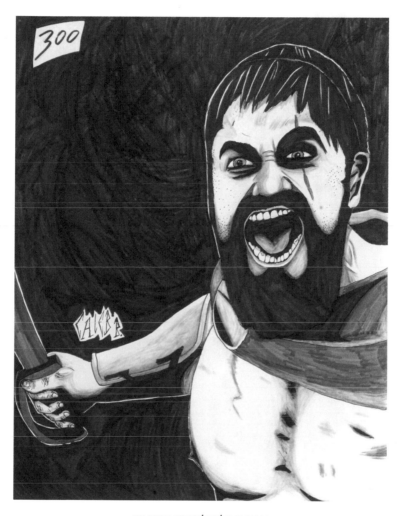

300, 2009, pen and marker on paper,
11 x 8 ½ in. (27.9 x 21.6 cm)

∾MARY BORDEAUX∾

In January 2004, I began working at the Heritage Center at Red Cloud Indian School in Pine Ridge, South Dakota, on the Pine Ridge Indian Reservation. In the late 1960s, the Annual Red Cloud Indian Art Show was set up for contemporary Native artists, and a collection began with the purchase of the first three prizewinners. Every year, the works purchased were stored in the church's basement, and in 1982, the Heritage Center was established to display the ever-growing collection. In 1996, the church where most of the collection was stored, burned down, and the Heritage Center sustained extensive smoke damage. Following the fire, the center was remodeled to accommodate collection storage, gallery space, and a gift shop. As I began my work as a cataloger at the center, I was taken into the collection storage area to record the objects in these rooms. Needless to say, I was a bit overwhelmed by the number of items and the storage arrangement, so I took photos to remember what it looked like before all the items would eventually be properly catalogued.

 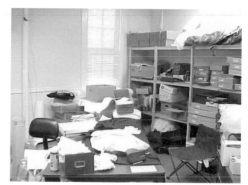

Collection Storage Before, 2004, digital photographs on DVD

∾NICOLE HARVIEUX∾

I am truly blessed and proud to be an American. I am not only a soldier for God, but also a soldier in the South Dakota Army National Guard. Over the past three years, I have taken more than 30,000 photographs and have written articles about training and the life of soldiers. I love what I do because I get to work with a community of people who base their lives around loyalty, duty, respect, selfless service, honor, and integrity.

Being a unit public-affairs specialist of the 109th Regional Support Group has allowed me to witness and document the quiet moments, as well as ones that overflow with excitement. We are an army of one, and each of us has our own story to tell about how the military lifestyle has changed us.

There are not many fields that one may go into where you can witness passion all around you. It amazes me how many soldiers give up precious time with their family, friends, and loved ones, all in the name of freedom. I feel very blessed to have been able to preserve the history of these soldiers and events. I love our country, and feel we are all very lucky to live here.

"Whatever you can do, or dream you can, begin it. Boldness has genius, power, and magic in it."—JOHANN WOLFGANG VON GOETHE

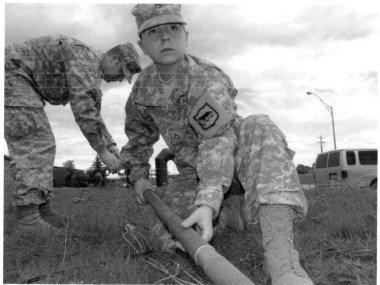

Tribute to Our Soldiers, 2009–2010, digital photographs on DVD

⋐⋟JAKE HERMAN⋞⋠

Jake Herman was my great-uncle, mentor, and teacher when I was a boy. I visited him whenever I got the chance, which was very often in the Pine Ridge of 1960. He would tell me stories as he painted on Masonite boards with oil paints.

I remember him saying to me, "Sometimes we can't pick and choose. You must be flexible enough to see whatever is at hand."

We worked with charcoal and pencil on paper, and with oil on Masonite, with him blending the colors on the board.

Jake taught me the way he was taught. I continue to paint in this way, and I teach it to my grandchildren and others who wish to learn. I am passing on this knowledge to the next generation.

BRUCE PRICE
Jake Herman's great-nephew

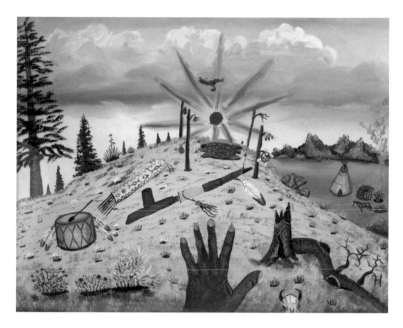

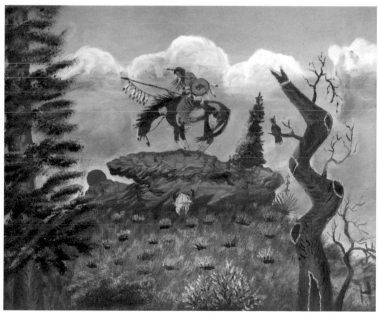

TOP TO BOTTOM: *Big Hand,* ca. 1960, oil on canvas board,
26 x 31 ¾ in. (66 x 80.6 cm), framed; *Horse on Hill,* ca. 1960, oil on canvas board,
23 ¾ x 27 ¾ in. (60.3 x 70.5 cm), framed

⫷BOB NEWLAND⫸

These works capture some things I have seen or experienced, and generally bear a pretty straightforward message. I was raised on a ranch where Wyoming, Montana, and South Dakota meet. I documented elements of that life for thirty years. For a time, I concentrated on producing rodeo action images.

My photographs were intended to appeal to a market, primarily the people I captured. Rodeo photography was—as I try to make all my endeavors—a way to earn at least a modest income while practicing a craft that, at its best, I viewed as art at the time. My rodeo photos are also historical documents of events and their participants. If art resulted, well, great! I shot my photographs on black-and-white film, and processed them myself.

When I shot rodeos—from 1977 to 1985—photography was centered on the darkroom. Rodeo photography was about capturing the peak of the action. While darkroom technique has been replaced by digital manipulation of contrast and exposure, a sports photographer still has to be able to anticipate and capture the peak of the action while being conscious of highlights and shadows. The action and the light cooperate in making a remarkable photograph. The selection on view here is from a collection of around 70,000 negatives, the vast majority of which might be considered of value only to those pictured in them.

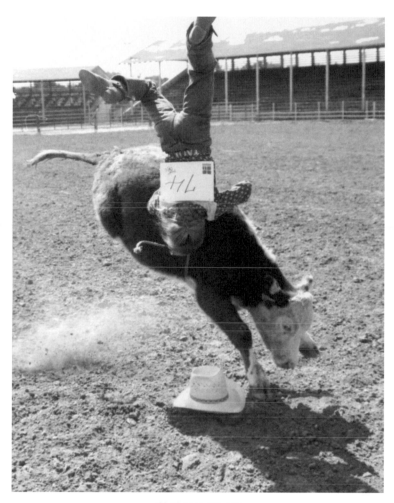

Oh. There's my Hat, 1982,
black-and-white negative paper, Giclée print, archival paper,
14 x 11 in. (27.9 x 35.6 cm)

～BERNIE PETERSON～

I started carving soap in the 1980s, probably because I saw an example somewhere or heard somebody talk about it—I don't remember, exactly. I sometimes carve things and give them as gifts. I never sell them. I have donated a couple of items to charity auctions.

Procter & Gamble sponsored the National Ivory Soap Sculpture Competitions from 1924 until the early 1960s. The tools and materials that are needed are inexpensive. I use a penknife or paring knife, a bar of soap, and a steady hand. Even if I am disappointed in or ruin the creation, I can still use it for washing.

When I begin a piece, I often say, "Let's see what is inside this bar of soap." In reality, I choose a theme or image that symbolizes the person for whom I am creating the piece. Sometimes the bar of soap seems to say, "I can be anything that you want me to be."

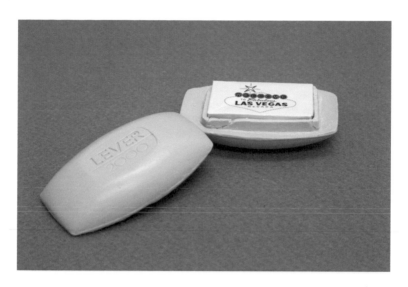

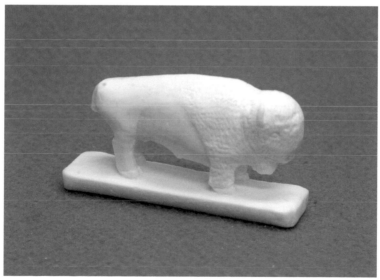

Soap Carvings: Soap Dish, Buffalo, 1983–1994,
soap, approximately 2 ½ x 4 x 1 ½ in. (6.4 x 10.2 x 3.8 cm) each

⸙ BRUCE PRICE ⸙

My art encompasses life. I paint what I see happening around me, current events, people and their idiosyncrasies: children, my grandchildren, nieces, and nephews, but not exclusively.

I teach the "mechanics of art." People ask me about different mediums, like acrylics, watercolors, oils, pastels, etcetera, and about their limitations. I teach picture-making, as well: balance; perspective; color; curves; and repetition in the composition (three hills, three trees, three warriors, three clouds, etcetera) that subliminally enhance the work in a subtle way, giving the work continuity.

I learned to paint from my great-uncle Jake Herman, who taught me the way that he was taught: hands-on. He sat me down and showed me how to use different mediums. He watched me work, and gave me encouragement with the drawings I produced.

I remember him saying to me, "This might come in handy sometime."

I worked many jobs, in factories, construction, landscaping, or whatever, but I've always created pieces of some type. I've studied artists and their work: Sargent, Cassatt, Degas, Renoir, and many others. A quote from Sargent stayed with me: When asked what he painted, he answered, "That which is before me." It reminded me of Uncle Jake, who used to say, "You must have the ability to paint anything with any medium at hand."

I try to create pieces that stand on their own merit, that have such beauty that people will want to take care of them. I have no favorite medium or genre, and as long as I have something to work with, I will continue to produce art. I am bound by honor to pass this on to those who wish to learn to make beautiful things.

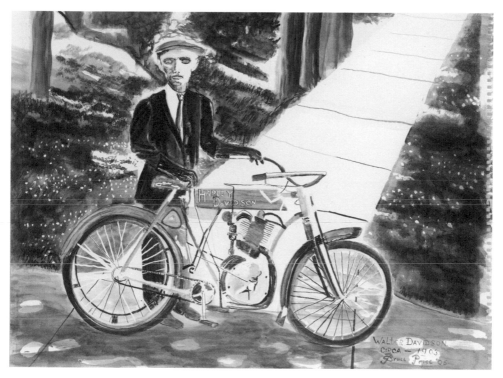

Walter Davidson Circa 1903, 2005, watercolor on paper, 18 x 24 in. (45.7 x 61 cm)

~JAMES WALLNER~

Wallner has a remarkable memory and loves to sit at the computer typing out each day's television schedule for PBS. Once you meet Wallner, he will ask you when your birthday is, and from that moment on, he will forever remember it. Wallner is a very unique artist, especially when he creates his *Masters of the Universe* drawings. He will start from the bottom of the page and work his way up. Most often, Wallner will only draw figures from the waist up, and only on occasion has he drawn some whole-body figures. Wallner loves to talk about comic-book characters, yoga, Mattel, the Care Bears, and Spider-Man. He enjoys looking at comic books, drawing, going to the lake, and meeting new people.

BRAD WINTER
*Director, Suzie Cappa Center for Art Expression and
Enjoyment, Black Hills Workshop*

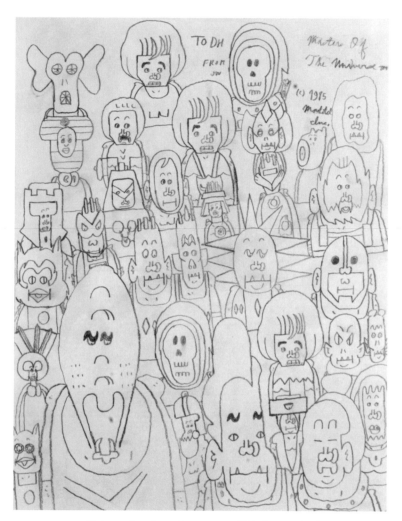

Masters—1985, n.d., pencil on paper, 11 x 8 ½ in. (27.9 x 21.6 cm)

~WINSTON-SALEM, NORTH CAROLINA~

Born in and from "the periphery," *People's Biennial,* the Southeastern Center for Contemporary Art (SECCA), and their founding missions seemed destined to convene. SECCA was established in 1956 to provide exhibition space for Southeastern artists who felt marginalized in a national context. Working as both catalyst and advocate, the organization subsequently grew in scope to include thirteen Southeastern states by the late 1960s. In more recent years, that vision has become international in focus, but with an enduring concern for the issues and idiosyncrasies that shape the region. However, as previously underrepresented Southern artists move fluidly into mainstream cities, the organization's historical reason for being comes into question. Faced with redrawn territories and proliferating galleries throughout the Southeast, SECCA wrestles with questions of site-based identity, provincialism, and the imploding binary of center versus margin. Standing inside and outside its namesake at once, SECCA's peripheral predominance has consequently been replaced with the re-envisioning of a "center" that—in geographic, semantic, and organizational terms—seems more elusive, and more fertile, than ever.

In this context, *People's Biennial* is a timely, and very necessary, platform to address the question of what being an "outsider" means today as an artist, an institution, and a city. As a concept, exhibition, and campaign, it navigates the ambiguous terrain between the Duchampian notion that everything can be art, and the hegemonic assimilation of objects made outside the discourse of "art." As the co-curators of *People's Biennial* step outside the usual parameters of the art world, their aim to find (and celebrate) people making or doing fascinating things not conceived of as "art" raises captivating social questions. In an age of decentralized information, digital communication, self-publishing, and near-instantaneous exhibition platforms like YouTube, Facebook, personal Web sites, and blogs, one no longer needs to *wait* for discovery. Bypassing the traditional (and often proprietary) enlistment of outsider artists by agents and galleries, the Enrichment Center in Winston-Salem, North Carolina offers a case in point—it provides artistic training, exhibition space, and commercial opportunities to adults with disabilities. Flea markets, social networks, and guerilla installations offer parallel avenues for other would-be artists—turning the insider-outsider binary inside out.

At this ambivalent intersection, *People's Biennial* opens up intriguing hybrids to individuals who had little previous knowledge about the co-curators, the biennial model, or ICI. Some are flattered by the invitation to participate in the project; some are bewildered; some are apathetic; and others refuse. There is no discernable pattern at any point in the solicitation, but the fray we see unfolding says a great deal about the sometimes-contentious nature of this project. Beyond an exhibition model, a catalogue, or a curatorial hypothesis, this is a social experiment where every action, incident, or response is part of the ultimate project. As fodder for discourse, *People's Biennial* has already succeeded before a single catalogue page has been printed, or a single work has gone up on the wall. Its anthropology, like that SECCA lives in the Southeast, will unfold beyond conventional notions of "the outside." Whether one is inside, external, on the fence, or passing through, the reaction to, for, or against this project is a critical part of its evolving constitution.

STEVEN MATIJCIO
Curator of Contemporary Art, Southeastern Center for Contemporary Art

∾ SYLVIA GRAY ∾

with the Elsewhere Collaborative

E lsewhere is a collaborative of curators, artists, and thinkers whose discovery of artist Sylvia Gray's work has unfolded into a new mode of curatorial and social play. For fifty-eight years, Gray created a series of businesses in downtown Greensboro, North Carolina: a used-furniture resale store; a national army-surplus-catalog company; a fabric outlet; and a vintage-clothing store. The series culminated in a three-story thrift store, an installation of mountainously heaped cultural artifacts. Discovered in its final form in 2003, having sat undisturbed for six years after Gray's passing in 1997, this vast puzzle has fueled the rearrangement of histories and artifacts by artists in residence, collaborative staff, and the public. The ongoing process of ordering has sparked an experiment in collaborative production around the simple conceptual boundary that nothing from Gray's work is for sale, and the internally circulating set of things forms the parameters for an ongoing project of transformation. Through Elsewhere's archaeologies and arrangements, traces of historic orders have emerged, cultural imaginations have surfaced, and the synthesis of intention and accident continues to aggregate since Gray first began her artistic enterprise.

ELSEWHERE COLLABORATIVE

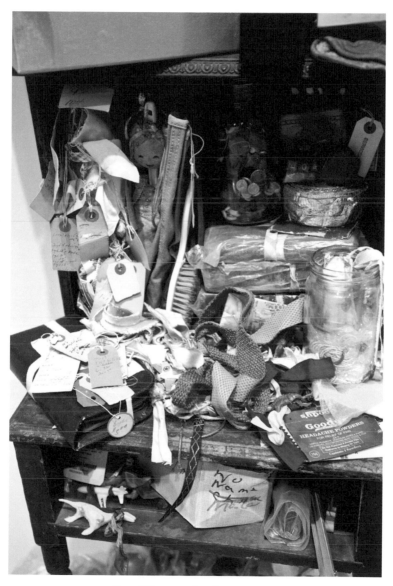

Natural History, 2010 (installation view detail)

∽JONATHAN LINDSAY∾

Jonathan Lindsay was born and raised in Winston-Salem, North Carolina. He was diagnosed with autism at three years of age. Although Lindsay is severely language impaired, his ability to communicate in his own way has never been hindered. Through extensive speech therapy, he has been able to add words that enabled him to communicate better. Lindsay attended the Winston-Salem Forsyth County Schools from ages five through ten. He completed his education at Bethesda Christian Academy, a school for special-needs children. It was there that he was able to begin to express himself in the worlds of music and art.

He enrolled at the Enrichment Center in 2004, where he quickly learned the fine points of the techniques involved in both painting and pottery. His works have a distinctive folk-art quality about them. His family members are the primary subject matter for his paintings. While he may be unable to express the things that are important to him verbally, his paintings are autobiographical in nature, and address not only his environment, but also the people that surround him. Works include locations such as the bowling alley where he bowls regularly, his barbershop, dentist's office, church, the Enrichment Center, the Percussion Ensemble where he plays the piano, etcetera. Lindsay shows a great sense of observation and an acute sensitivity to his surroundings, which are reflected in his works—from the tractor in his garage to the shade of green on highway signs.

BRIGITTE LINDSAY
Jonathan Lindsay's mother, and
SHAYNA PARKER
Visual Arts Specialist, the Enrichment Center

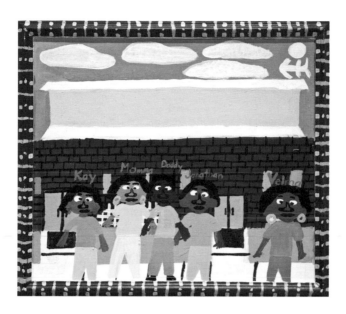

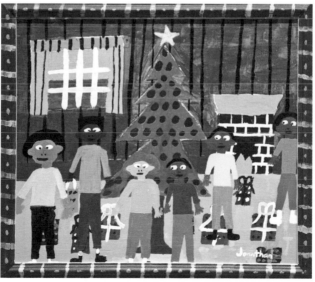

TOP TO BOTTOM: *Off to Church*, 2007; *Christmas at Grandma Pugh's*, 2004,
both acrylic on panel, 18 x 20 in. (45.7 x 50.8 cm) each

ᖰRAYMOND MARIANIᖱ

Raymond Mariani spent his formative years in the suburbs of New York City. Diagnosed with autism before his second birthday, Mariani had severely limited verbal communication abilities for the majority of his childhood. From a very early age, however, he shed light on the inner workings of his mind through artistic expression. His early subject matter dealt with the inanimate— road signage, flags, corporate logos, etcetera—with impressive realism and skill. As the efforts of his educators and family paid dividends, and Mariani's social and verbal skills improved, his art began reflecting his increased connection with and interest in the world around him. Alongside depictions of streetlights and stop signs came representations of family members, cultural figures (such as the Muppets) and wildlife, often imbued with a whimsical sense of humor that distinguishes his work to this day.

Since his family's move to North Carolina in 2001, Mariani has spent the better part of his days at the Enrichment Center in Winston-Salem. This singular institution has fostered his innate creativity, allowing him to bring it to new heights. His prolific output reflects the span of his past in street scenes, family portraits, and pop-culture caricatures. A recent interest in his work has been self-portraiture, as he now depicts himself in social situations, interacting with the world, unfettered by his condition. This development is a testament to the power of Mariani's art in enriching his own life, and the lives of those around him.

JOSEPH F. MARIANI
Raymond Mariani's brother

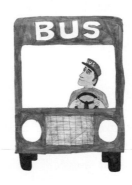

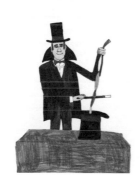

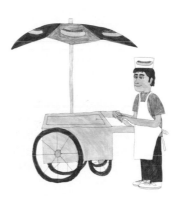

LEFT TO RIGHT, TOP TO BOTTOM: *Plumber,* 2010; *Bus Driver,* 2010; *Magician,* 2010; *Hot Dog Man,* 2010, all pen and Magic Marker on paper, dimensions vary from 11 x 14 in. (27.9 x 35.6 cm) to 14 x 15 in. (35.6 x 38.1 cm)

ᴔJENNIFER MCCORMICKᴖ

My works in *People's Biennial* are medical demonstrative evidence. Their subjects are people who have been injured through someone else's negligence or malice. Their purpose is to show what cannot readily be seen about a victim's experience, and to simplify complex medical information. While all of the faces and names have been changed to protect identity, the stories are real and have all been tried in a court of law. Every detail I draw correlates with facts taken directly from the client's case file, which may include medical records, police reports, photos, and other data submitted to me by a trial attorney. Ultimately, the attorney's expert witness—usually a medical doctor— uses the artwork to help tell the victim's story at trial, while on some occasions I need to appear in court to explain how I have created the picture. If the images are inaccurate or misleading, the artwork cannot be used to inform a jury.

Sometimes my work is used to help defend physicians wrongly accused of malpractice, or to reveal details that make some lawsuits frivolous. I feel that careful research and quality artwork are as important as medical accuracy in conveying the truth.

With the requisite life-drawing skills and a foundation in science, I was accepted as a graduate student into the Department of Art as Applied to Medicine at the Johns Hopkins School of Medicine. There, I had the opportunity to attend classes with medical students, enter operating rooms, and stand beside surgeons as they explained surgical procedures to help me turn medically complex narratives into textbook illustrations. I also learned illustration techniques from some amazing classically trained artists who were my teachers, including Ranice Crosby—a student of Max Brödel whose work still inspires me. I formed Art for Law & Medicine, Incorporated, a medical-demonstrative-evidence studio, to help victims recover money for their losses, suffering, and future medical expenses.

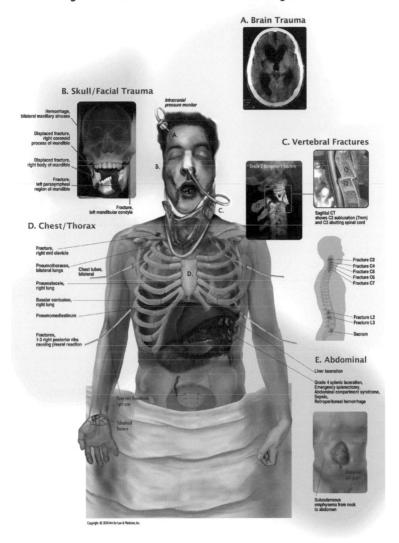

Medical Demonstrative Evidence, 2006–2010, commercial inkjet print,
40 x 30 in. (101.6 x 76.2 cm)

⌒JIM MCMILLAN⌒

When I was young, my family would drive the two-lane roads to visit my grandmother, aunts, uncles, and cousins who lived on farms in rural Robeson and Harnett counties, in eastern North Carolina—land that has been in the family since the mid-1700s and early 1800s. The Smiths lived in a two-story house with a two-story front porch, all built of heart pine, surrounded by giant oaks, tall pines, mysterious patches of woods, and vast fields, dirt stained with blood in the last battles of the Civil War. Ghosts. Between the big house and the spring and the woods, empty slave cabins stood, leaning, crumbling into the soil. More ghosts. Grown-ups sat on the porch and told stories, talked about politics, family, and the meaning of life while bugs flew tracers around the yellow porch light, and thumped and clicked off the walls. It was the same in Robeson County on the porch of the one-story McMillan farmhouse. From the quiet voices of these quiet, humble people made of love, blood, and steel, my parents among them, I absorbed laughter, joy, death, loss, war, politics, family, and ruminations on the hereafter. The sunrise and sunset over flat fields, distant tree lines, a swamp. The Lumber. The Waccamaw. The Cape Fear. Rivers. Leave for home in the city late in the day. I went to school. I became a lawyer. After thirty-five years, I tried to quit law to become what? An artist? I could not say the word out loud. I thought I had not earned it. But I had no choice. I had to photograph what I saw, what I felt, the trees, fields, creeks, streams, swamps, rivers, abandoned buildings, and the faces of family, friends, and strangers. To celebrate them. To revere them. To share them. To stand and wonder at them.

TOP TO BOTTOM: *Bryan, Andy, Adam, Horseshoe, N.C.*, ca. 1990;
Chillin', Ellerbe, N.C., ca. 1980, both archival dye inkjet prints, 15 x 20 in.
(38.1 x 50.8 cm) each

PRESLEY H. WARD

Critics often ask me where I get all of these complex ideas from. Well, here is the answer to their question: I often thought myself to be an instrument inspired by dreams, with a psychological relationship between illusions and the subconscious. This is consistent with some of the comments that I have received from people who have seen my work, including other artists. A lady once said that she was glad she was not inside my head. I replied that I, too, was glad that I'm not in there.

Another friend of mine, who used to be homeless, and for whom I have a lot of respect, once said that I was a real professional. And another one of my friends said I should be in a mental institution, which might not be a bad idea, because it would probably improve my talent, and other skills, too. Some think that I have too much imagination. But no matter what the case may be, they all love my artwork. See for yourself, and you be the judge.

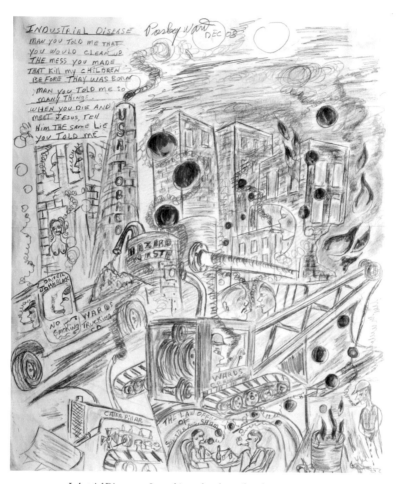

Industrial Disease, 2008, graphite, colored pencil, and crayon on paper,
17 x 14 in. (43.2 x 35.6 cm)

ᖰSCOTTSDALE, ARIZONAᖳ

As a contemporary-art curator living and working in Arizona, I am always conscious of my relationship to the larger art world. Being based in locations such as Scottsdale requires a strong effort to have the work being created here considered in the national dialogue on contemporary art. Accessing significant national exhibitions and events is also challenging. However, there exists a freedom to experiment that I relish in working in an environment with fewer hierarchies and limitations than in more established art communities. Moreover, as one of a handful of contemporary curators here, I may hope to make a greater impact on my audience than I might in a larger art center. It is likely that this same dichotomy exists for artists working here. Consequently, I thought *People's Biennial* would be a valuable project for the Scottsdale Museum of Contemporary Art, and one in which I wanted to participate.

The notions of "periphery" and "center" are integral to the concept of *People's Biennial*. For the curators, the terms are intended to apply not just to geography, but also to artistic and curatorial practice. Initially, I had been concerned that these ideas of "periphery" and "center," as presented, were conflated and therefore problematic. This aspect of the project is fascinating, and has been difficult for many in this community to understand. The practices of making and curating art are loosely and rather nebulously defined; they operate on a spectrum, ranging from traditional conceptions to totally unexpected forms. However, as I came to understand the intentions of the curators, I realized that the blurring of boundaries and a semantic reconsidering are precisely the point. A particular challenge for me, in light of the artistic production in this community, has been drawing a clear line between professional and nonprofessional artists—which is exactly why the project is provocative.

Jens and Harrell have uniquely open ways of encountering the world. After exploring my community with them, I felt inspired, like I had a new lens with which to view my city. I find myself noticing things more now, paying attention to church architecture, as Harrell did, and keeping an eye out for piñata stores and good hand-painted signage. I also realized that it was refreshing to discard the labels and categories that had previously concerned me. So maybe this exhibition will not be an opportunity for our talented, professional local artists to be considered for a biennial and gain national recognition, but it will surely be an opportunity for all of us to rethink why we value things like biennials, curating, and art in the first place.

CASSANDRA COBLENTZ
Associate Curator, Scottsdale Museum of Contemporary Art

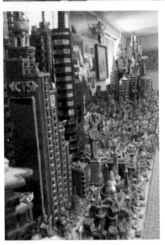

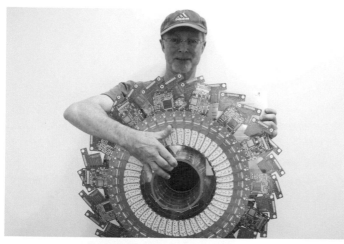

∼GARY A. FREITAS∼

SINGULARITY—Arising Electronic Consciousness

Computer scientists have speculated that within simple twenty-first-century circuit boards exists the genesis of a new consciousness, which they have termed "Singularity," the technological creation of smarter-than-human intelligence. The invisible geometry of this computer consciousness is all around us in our daily lives. This omnipresent circuitry inhabits our cell phones, planes, cars, computers, social networks, medical devices, and toys. The works presented here are part of an experimental art project that utilizes the hidden and common detritus of the modern high-tech world: printed circuit boards.

Science and art have converged in the circuit board to make an important statement about their necessary relationship. Within the rich, complex tapestry of electronic circuitry, hidden in the architecture of computer intelligence, is the revelation of an invisible micro-aesthetic. This work explores the nexus of art and science in order to reveal a profound aesthetic platform that shapes our present and future. While many traditional forms of art have explored this reality, the imagery created here is an exploration of the underlying patterns found both in art and in chaos theory.

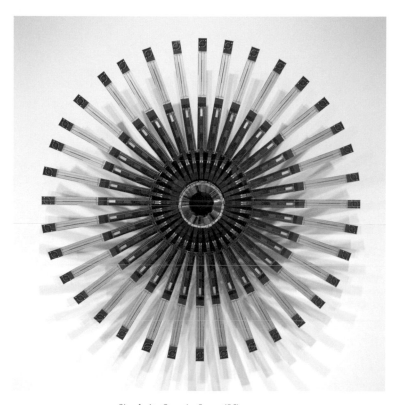

Singularity: Operating System (OS): 1.2.0, 2010,
acrylic paint and computer components, 50 x 50 x 13 in. (127 x 127 x 33 cm)

⟊JIM GROSBACH⟊

CLAYKIND: A life-long imaginative journey
of a civilization made of modeling clay people and their cities

In April 1955, I built a modest city out of Plasticine modeling clay to an approximate ½oo scale (½ inch equaling ten feet) on a three-by-two-foot tabletop. I made tiny "clay people" to inhabit it, gave them a government, and for the past fifty-five years have been building this universe further, enjoying an on-going "hobby" of political intrigue, wars, and construction projects. The milieu is somewhat akin to the computer virtual game *Sim City* with my clay cities acting instead as a "hard copy."

Today, on a twenty-by-twelve foot enclosed porch room at my wife's and my home in Buckeye, Arizona, I have an array of cities, mountains, lakes, and rivers, which utilize at least two-and-one-half tons (yes, tons) of Plasticine. The civilization has its own weights, measurements, rules of physics, and political divisions. I have written two large volumes on the civilization's history as well as its religious beliefs and philosophies. The cities are always in a state of flux with buildings being replaced, added to, or moved. The buildings are not sculptures, but hollow, constructed edifices, with a great deal of details, many complete with office cubicles and even tiny furnishings.

The various nations (some located in other places about our home) have different types of political governments, ranging from autocracies, monarchies, to democracies. The cities publish newspapers, some of which are presented here, bearing dates in "Clay Year", where September 2010 is year 666 (based on the 666 months elapsed since April 1955).

The display *Between Innings* is a stand-alone exhibit built specifically for *People's Biennial*.

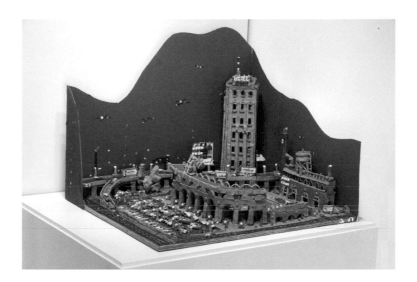

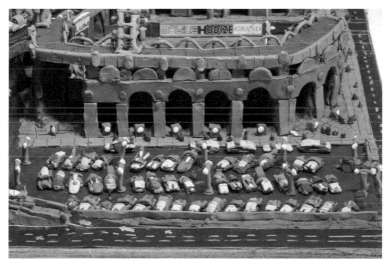

Between Innings, 2010 (installation views, detail on bottom)

⨾⨾ DAVID HOELZINGER ⨾⨾

The Accidental Artist: A Life in Pictures

It started with a series of chance incidents. When I was fifteen, my father brought a calendar home, a kind of desk ledger. I set it on my desk and started crossing off the days, sometimes wrote a note, and eventually a couple of simple drawings. Then, one day, a friend drew a series of pictures in it, which later prompted me to start drawing an image each day. Gradually, these daily drawings evolved into a portrayal of each day's events, or my reaction to them. My hand and eye began learning how to pack my life into square-inch spaces.

Quickly, this turned into an obsession, a compulsion . . . but it was also a time for contemplation, and the calendar took on a life of its own. Sometimes, the act of drawing was the best part of the day. It became a diary of events—more than that, a reflection of my inner life in symbolic form. This went on for over twenty years, constantly evolving, until life became too full.

Today, whenever I want to meditate on where my life is going, I pick up a few of my calendars and look through them, and somehow this brings me back to my center. Like watching a movie that encompasses a broad sweep of history, poring over them allows me to be able to relive the past, day by day, in a way that would otherwise not be possible.

What seems amazing to me is that, without a conscious decision, this thing, this calendar, seems almost to have created itself—and it all happened by accident.

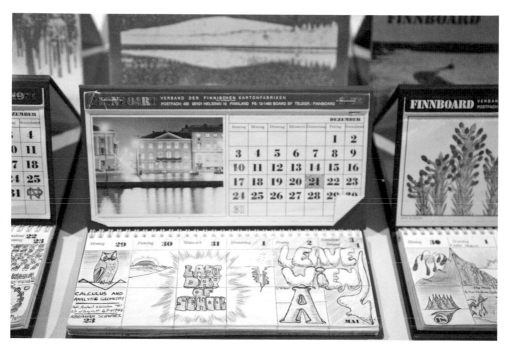

The Calendar, 1970-1996 (installation view detail)

⮜BEATRICE MOORE ⮞
and the Mutant Piñata Show

The Mutant Piñata Show has had several incarnations over the years, but was originally established in March 2002 as a call to the public to exhibit their piñata creations. It was held during the annual Art Detour, an open-studios event that I had started in Phoenix, Arizona, years before, in 1989. The show was held for two consecutive years at my studio, Weird Garden. In 2008, I decided to revisit the idea, and to move the exhibition to the Bragg's Pie Factory building, which my partner, Tony Zahn, and I had recently renovated. The historic 15,000–square-foot warehouse, with its dramatic steel bowstring-truss roof, was the perfect place to hang piñatas.

A call for entries for the Mutant Piñata Show is made every winter, and when the piñatas arrive in the spring, it's like Christmas, full of surprises as to who is participating, what they have made, how many piñatas have actually come in, or what kind of unusual materials the artists have utilized. Everything submitted is included in the show and hung together, whether it was created by a child, an elementary school class, a university student, an artist, or anyone else who wanted to try his or her hand at piñata-making, perhaps for the first time. Regardless of their makers' skill level, when all the piñatas are hung together, they produce a joyful and quirky visual cacophony that is thoroughly enjoyed by the many visitors who come to see them.

Mike Maas, *Vampire P.S.A.,* 2010, corrugated cardboard, acrylic, spray paint, gold leaf, pipe cleaner, 36 x 27 x 19 in. (91.4 x 68.6 x 48.3 cm)

∾JOSEPH PEREZ∾

I was born in Phoenix, Arizona, where I learned how to make my art. While in the first grade, I helped paint my first mural project, and I loved it. From then on, I was always doodling and drawing. I would always try to make art whenever I had the chance, but unfortunately, growing up in West Phoenix, in an environment that wasn't very good for bringing arts to the kids, I rarely had the chance to pursue my passion. In high school, though, I was introduced to the art of graffiti and the whole new world it brought with it. During that time, I also met an art form called breaking, or, as we call it, b-boying. I had always liked it, and I would watch my older cousins do it when I was younger.

By the time I graduated from high school, all I wanted to do was dance and make art. After getting into trouble while doing graffiti, I taught myself to paint on canvas. I found that my paintings were the voice of my mind and heart, and breaking was my physical expression. It wasn't until 2009 that I had the idea of mixing the two art forms into one.

That year, a couple of friends and I started to roll out huge pieces of drop cloth, paint our hands and feet, and dance on top of the canvas. I wanted to show people that we are artists, too. When we are out dancing to the beat, we're creating art. As artists, we put so much heart and soul into our work, which sometimes doesn't get recognized.

Sound in Color: Friday Night, 2010, acrylic on primed canvas, 48 x 84 x 3 in. (121.9 x 213.4 x 7.6 cm)

ANDREA SWEET

This grouping of black memorabilia is called *Shade*. That's street vernacular for disrespect. That was precisely the point when the items were manufactured. They were meant to dehumanize, degrade, and devalue black people in this country. If you don't think of us as human, you're not inclined to treat us humanely. These ugly, racist objects were essential tools in the fight to deny us basic human rights during Reconstruction, and well into the Civil Rights era.

The majority of the items on view here are usually on prominent display in my home. I am always searching for new pieces to add to the collection. Why would any sane person seek out, acquire, and surround herself with objects of hate? I do it for two reasons. I would much prefer that the objects belong to me, rather than to someone who buys into the racist ideology they represent. The other reason is the perspective the pieces give me.

I look at my collection, and reflect on the enormous amount of energy that went into terrorizing, stereotyping, and demoralizing black people in America. Yet we're still here. We're stronger than ever. We're full citizens. And we're making a positive impact on the world. I get strength from that. And I'm filled with the certainty of a future that holds infinite possibilities. I wish the same for anyone who views my work.

94

Shade, 2010 (installation view detail)

∾PAUL WILSON∾

I love the American 1950s, and I pick and choose from that era what I wish. I chose my house, furnishings, and clothes from that period. I wondered if I could live the lives of the classic nuclear family. I proved I could by experimenting with taking multiple photographs of "my selves" in various guises and hand-pasting them together onto a background board. I enlarged these small collages into larger pieces, which I hand-colored and enhanced, and then re-photographed, "shrinking" them back down to a seamless "snapshot" size. This enabled me to fill vintage photo albums with the life and times of the made-up Kimble family. Dottie, the matriarchal stereotypical 1950s wife, oversees her brood, and their usual—and occasionally very peculiar—activities, all caught in glorious Ansco Color. As this album evolved, I shot videos of home movies to supplement the photos. No computer processes were involved. My beloved Dottie lives on today, in fourteen-inch-doll form.

My latest work consists of videos and photographs chronicling Dottie's life, in miniature mid-century sets. As she evolved, so too did I, her creator. Often, Dottie and I appear in the same scenarios. Several re-painted dolls interact in our world, including celebrities of the past and present, and many others.

Her—that is to say, our—activities are occasionally questionable, as we currently live in contented bliss with a young Lee Harvey Oswald, whom Dottie caught when he was young, and turned to the Good Side. I crushed him, too, and the literal love triangle is quite colorful.

Rainbow-colored, in fact. . . .

Dick & Dottie Kimble's Family Photo Album, 1947 to ?, 1993–1997 (detail)

A two-car caravan dumps two curators, two directors of arts organizations, one student intern, an anthropology professor, and a photographer onto North Fifth Street in Philadelphia. Undeterred by the multiple parking tickets already acquired, they will visit two studios, take in two impromptu musical performances, and later search for robots made from trash, which they have been told await them further down the block.

This is curating *à la People's Biennial*. It seems strange to point out that this is indeed curating, but I have never done this before. First off, I have never been to this part of town, though I have lived here my whole life. I have been on studio visits before, but they have never entailed a jam session, replete with conga-playing artists on accompaniment. And it would be safe to say that I thrive on schedules. Once the hunt for robots trumped the agenda I had set, I realized we were on to something different: a new curatorial methodology that kept the door open for anything and anyone to come through—hoarders, faux Frenchmen, ladies with rat tails, teenage-anarchist mayoral candidates, stay-at-home-mom painters, retired restaurateur-photographers, performance barbers, horses, and, of course, the aforementioned robots.

Such a methodology has its ups and downs. Seemingly ho-hum gallery activities, like filling out loan forms with an artist, become hidden-camera fodder for upcoming performance pieces. While going over paperwork with artist and media-provocateur Howard Kleger at his workshop-apartment, a colleague and I saw him suddenly toss a half-eaten candy bar over his shoulder onto a pile of cardboard a few feet away. With some kind of camera always rolling in the apartment, we assumed that whatever reaction we gave would make it into his next film project. Thus, we played it cool, pretending not to notice. Only later did we discover that he actually had another artist listening in from beneath of the pile of cardboard—he was just hooking her up with a snack, since we were taking so long.

Yet *People's Biennial* also elevated the seemingly pedestrian to the euphoric heights of the once-in-a-lifetime: random hangs with a barber—in this case, infamous Philly hairstylist, sculptor, inventor, poet, and bon vivant Julius Scissor—blossomed into hours-long conversations on topics ranging from the bizarre to the sublime. Would that we could have wedged Harrell's new Scissor-sculpted hairdo into the show. Maybe next time.

Perhaps, then, the greatest strength of a project like *People's Biennial* is also its greatest weakness: serendipitous and ephemeral, many of these fantastic experiences never crystallized into locatable artworks that could be translated to a gallery setting. *People's Biennial* has challenged the staff of Haverford's Cantor Fitzgerald Gallery to consider how we can craft exhibitions that cultivate and preserve these kinds of experiences. How might we expand that initial caravan of two curators, two directors of arts organizations, one student intern, an anthropology professor, and a photographer to include everyone who visits the gallery? And how can we portray those experiences beyond the mere physical anchor of an artwork on a pedestal or wall? Difficult questions, but we're looking forward to more parking tickets.

MATTHEW SEAMUS CALLINAN
Campus Exhibitions Coordinator, Haverford College

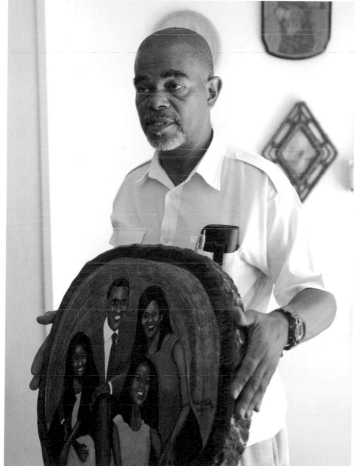

～LAURA DEUTCH～

We must document where we are, so we can articulate where we want to be, and begin to imagine how to get there.

Messages in Motion (MIM) is a blue van. It's a creative process. It's a model of communication and exchange. *MIM* believes that media can be independent, community-driven, and representative of diverse voices, perspectives, and styles that reflect our uniqueness as individuals and speak to our needs as communities. However, most of what we see, hear, and read comes from corporate media, the dominant communications system in the United States, where the focus is on making money and selling products. Corporate media does not reflect the interests of people or our daily experiences.

MIM supports first-time media-makers in the production, distribution, and exhibition of short video postcards that express their ideas, concerns, and questions about themselves and their world. The postcard framework leads the users to communicate a succinct personal or social message, while documenting their environment.

The videos are created by participants in a five-to-eight-hour workshop, and are then shared with other communities through screenings and in subsequent workshops. They are also tagged to a growing online map, where viewers can sort videos by theme, reflecting on similarities and differences while seeking inspiration from one another. By networking people and places, *Messages in Motion* activates relationships and promotes self-expression as a step toward social change.

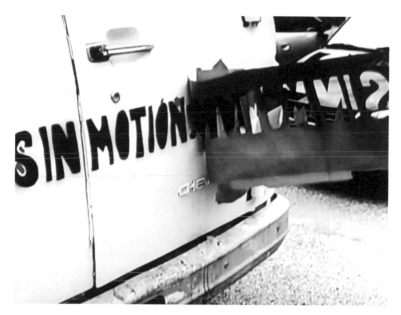

Messages in Motion, 2009–2010 (video still)

JORGE "EL CHE" FIGUEROA

I document visual moments of humanity, particularly of people whose lives would otherwise be bypassed by art and history. I study people. I like to know where they are, how they live, who they're with, what they do, and what type of individuals they are. I try to blend in and remain unnoticed as I work to capture the decisive moment that will encapsulate a person's life story in one image. That moment, saved from oblivion, will never repeat itself.

It is important to me as an artist to present the viewer with soul-searching images that will spark a conversation. What is this story about, and how does it relate to your own life?

My goal is to portray my subjects' environments, lifestyles, sorrows, triumphs, and values in a dignified manner. If my pictures evoke compassion, admiration, and introspection, I've done my job well. Furthermore, my photography is an agent for social and historical action. Most of the people I photograph have no one to record their stories; they have seldom seen a picture of themselves. I take the essence of their spirit and engrave it permanently in a tangible memory. Now I have something to give back. I present them with a visual moment of their lives—a timeless gelatin silver print. This is the most rewarding part of my craft.

Untitled, 2009, black-and-white gelatin silver print, 12 x 15 in. (30.5 x 38.1 cm), framed

◃MAIZA HIXSON▹

I created *Men Are Much Harder 2* in anticipation of an exhibition that I organized in 2006 in Louisville, Kentucky, entitled *Oh Boy: Men and Masculinity*. I was inspired by a study conducted by Beth Eck of James Madison University, who researched ways in which men and women responded to images of the male and female nude in pornographic, medical, and artistic contexts. *Oh Boy* featured photography and videos by several contemporary artists, who depicted men in various states, from bodybuilders working out to patients undergoing gender-reassignment surgery. One week prior to the opening of the exhibition, I asked people in to the gallery where *Oh Boy* was to be held, and invited them to preview reproductions of the works in the show. I interviewed and videotaped the participants on their subjective reactions to the artwork. After recording the volunteers' responses, I edited the footage and presented it as an audio-visual introduction to the exhibition. These participants returned the following week, some with family and friends, to attend the opening and to see their interviews.

In her research, Eck stated, "Heterosexual men respond to men in two ways—with overt rejection and with stated disinterest." If this is true, then is it possible that some of these individuals create a hostile environment for others to look at and respond to images of men? While *Men Are Much Harder 2* is an attempt to generate increased public interest in art through conversation, it is also a reflection of my desire to create an environment for people to talk openly about the male body.

Men Are Much Harder 2 (Extended), 2006–2010 (video still)

⤳HOWARD KLEGER⤳

My collection of works can easily fit into the category "living arts," a group which to me also includes "multimedia," or conceptually driven motifs in the format of film, sculpture, performances, staged events, environments, diagrams, conscious post- figurative fine-arts pieces, music, writings, and inventions. All of these pursuits would appear to the general audience, the regular public-at-hand, and even to my closest friends and arts associates, as disconnected things. But they all should be considered as units that help in the format of my biography, working and readjusting amongst themselves in the three-DVD Howard-set world.

This work has been formatted to pinpoint the middle of an ongoing timeline that began with the documentation of my work in 1996, with a single film clip from Kutztown University in Pennsylvania. Seph, a friend, decided to pick up the pieces and continue the story of my life, as he began working on a second film, *Howard2go*. This led to the idea of a larger collage-like, three-part film series.

The accompanying diagrammatic sketches, and samples of my work formatted as drawings, are direct and indirect references to the films' content. I felt it was appropriate to capture a glimpse of my elusive works. However, I still have ever-burgeoning clouds of thoughts, and I will continue gathering and sculpting experiences and objects into the reality I see fit for the final film in the series.

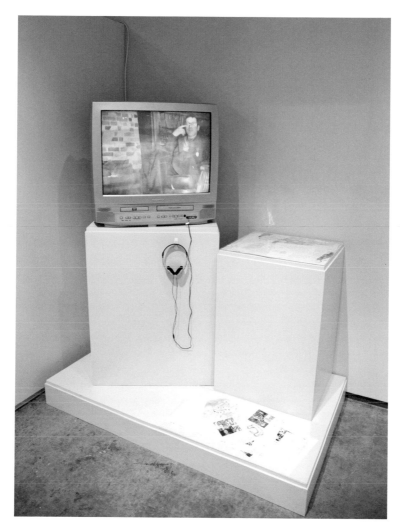

Installation view from the Dahl Arts Center.
Howard2Go, 2009, and *Collection of Drawings and Writing*, 1996–2010

≪CYMANTHA DIAZ LIAKOS≫

I made most of my drawings between the ages of eleven and fourteen (over thirty years ago), when I was consumed with daydreams as an avenue of escapism from divorcing parents and later adolescent insecurities. I would spend hours devising dialogues and storylines as I drew characters. Some fantasies were about "nice, normal, stable" families that I wished I had. I notice that many of my drawings feature redheads, and believe this was influenced by my childhood best friend and her family, who epitomized a traditional family to me, with Friday-night rituals of hamburger-and-milkshake dinners followed by watching TV—*This Is Tom Jones* and *The Brady Bunch*. One recurring storyline was about an older couple, Henry and Henrietta, who bickered but remained inseparable partners. These scenes were set in ordinary places, like a kitchen or beauty shop, with Henrietta always in curlers and a housedress.

I much preferred drawing women rather than men, and over time, my work became almost exclusively of women. I loved to draw different women's faces, some movie-star beautiful, others frighteningly ugly or with exaggerated features. I spent a lot of time watching old black-and-white films, and was inspired to draw women with 1940s hairstyles and wardrobes, creating dramatic storylines and dialogues similar to what I was seeing. I particularly liked the vampy characters, and would usually start with those.

My father was the biggest supporter of my artwork. He believed I had real "genius," and sent drawings to *The New Yorker*. He found venues for exhibitions of my drawings, and several pieces actually sold. We aspire to collaborate one day, with him writing a story and me illustrating it.

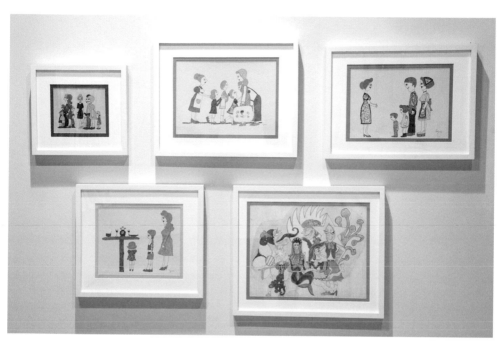

Installation view from the Dahl Arts Center. LEFT TO RIGHT, TOP TO BOTTOM:
Back to School, 1974–1975; *The Parents Return Home From Trip,* 1974–1975;
Meet the Teacher, 1974–1975; *Time to Eat,* 1974–1975; *People Are Strange,* ca. 1976

～ALAN MASSEY～

Pavement Cracks and the
Start of the Line Compositions

Sometime in 2007, I started to photograph pavement cracks, documenting an extensive catalog of beautiful decay. Each image was a study that used the joints of the pavement and the crevices as compositional elements. I began to look at these photographs as a starting point for further compositional explorations, seeing the joints as lines and the tonal qualities of the pavement as Color Fields. I then reinterpreted these in collages, which quickly went in a new direction.

The collage work in this series is a tangent from this line of exploration. The compositions are informed by this process of discovery, from the pavement crack that first caught my eye to the rough line found in a magazine used in the collage to represent it. Lines, shapes, colors, and gradients are found and captured, brought together and released. They are no longer representations of found compositions, but instead are self-referential compositions that found themselves in the generative process: the first line, color, or shape then informed the next, and the next, until the composition felt complete.

Line Composition Series, 2010, plastic laminate chips, vinyl wall covering,
craft tape, magazine paper, 4 x 2 ½ in. (10.2 x 6.4 cm) each

~ANDREW SGARLET~

I began painting and drawing in 2003. My early interests were strong or forced perspectives and Surrealism. From my early work of imagined objects or landscapes, I looked at the symbols that are around us. The subject of my work is the presence of objects that exist on their own, outside of our imagination and our mind. That is to say, we can see them without our illusions, our thinking, or our cultural references interfering.

Art can be mostly about illusions and commentary, but I believe that it is also a place where the mind can pause, and seeing can become an action in and of itself. I have been trying very hard to see beauty. I know I have seen it before, but it is vague and exists as more of an idea than a reality. The world hasn't changed, but I guess I have. Beauty was always in the act of making, which for me has often meant seeing each part of something and recording it, like a needle measuring the movements of the Earth. When I look at things and discover what color they are, I am often surprised—I always expect them to be brighter or more brilliant than they are. Painting corrects these expectations.

When you stop looking for beauty, you find yourself seeking out what is interesting or engaging in the world. Interesting things and topics slowly become your personal idea of the beautiful.

TOP TO BOTTOM: *GPS,* 2009, oil on linen, 8 ½ x 7 x 1 ½ in. (21.6 x 17.8 x 3.8 cm); *Yellow Pages,* 2010, oil on linen, 15 x 10 x 1 ⅜ in. (38.1 x 24.4 x 3.6 cm)

ROBERT SMITH-SHABAZZ

I am a native Philadelphian, born in 1949, and a multidisciplinary artist. I am also a musician, and play saxophone and percussion. If I were to give a reason for my work, I would say that my main motivation is to raise the level of consciousness in people of the good in using the gifts and skills that God has given us. I am talking about serving humanity in whatever capacity one has. For example, as a musician, I simply play my heart out if I see that one person is listening. This sometimes opens up a situation that allows for conversation with that person, at which time sharing can take place on any level.

My wood carvings consist of both functional and nonfunctional art. I make staffs and canes, address plates and all kinds of things, many of which can be customized based on people's suggestions. One of my specialties is carving images, including portraits, into wooden conga drums (I also provide instructions on how to play). One of the things that brings the most joy to my heart is when I carve a portrait of somebody's deceased loved ones—when I see the look in that person's eyes as he or she first glimpses my work, and is able to hang it somewhere in full view. To me, it's about encouraging others in a time when they really do need people.

Tupac, 2007, watercolor on carved wood,
11 ¼ x 8 ½ x ½ in. (28.6 x 21.6 x 1.3 cm)

Note: Height precedes width precedes depth; all dimensions provided are for unframed work unless otherwise specified. Unless otherwise noted, all works are courtesy the artist.

CALEB BELDEN
(b. 1995, Fairbanks, Alaska)
Lives in Rapid City, South Dakota

300, 2009
Pen and marker on paper
11 x 8 ½ in. (27.9 x 21.6 cm)

Brent & Caleb in Car; Cannibal Corpse Video; System of a Down B.Y.O.B.; Led Zeppelin by Caleb; and Metallica by Caleb, 2009
Single-channel color video with sound
4 mins., 43 secs.

Cannibal Corpse, 2009
Pen and marker on paper
8 ½ x 11 in. (21.6 x 27.9 cm)

Metallica, 2009
Pen and marker on paper
8 ½ x 11 in. (21.6 x 27.9 cm)

MARY BORDEAUX
(b. 1976, Pine Ridge, South Dakota)
Lives in Pine Ridge, South Dakota

Collection Storage Before, 2004
51 digital photographs on DVD

LAURA DEUTCH
(b. 1980, Allentown, Pennsylvania)
Lives in Philadelphia, Pennsylvania

Messages in Motion, 2009–2010
Single-channel color video with sound
110 mins.

**ALLY DROZD
WITH JUDGE EVANS
AND THE PORTLAND
COMMUNITY COURT**
(b. 1986, Portland, Oregon)
Lives in Portland, Oregon

Donovan Brown
Untitled, 2007
Pencil and colored pencil on paper
17 x 15 in. (43.2 x 38.1 cm), framed

Zack Hamilton
Name face. Game. Game., 2010
Enamel paint, molding, and ink on wood panel
12 ½ x 9 ½ in. (31.8 x 24.1 cm)

Cameron Hawkey
It's a Dismissible Case, 2010
Ink, watercolor, and gouache on paper
11 x 14 in. (27.9 x 35.6 cm), framed

Darig Herandez-Cruz
Untitled, 2010
Acrylic on canvas
24 ¼ x 35 ½ in. (61.6 x 90.2 cm)

Daniel Koszorus
Self-Portrait in the Future, 2009
Chalk, pastel and watercolor on paper
16 x 12 ¾ in. (40.6 x 32.4 cm), framed

CJ Randall
March 20, 2010
Watercolor on paper
25 ½ x 33 in. (64.8 x 83.8 cm), framed

Rueben Lee Torres
Untitled, 2010
Colored pencil, ink, and pastel on paper
9 ½ x 11 ¾ in. (24.1 x 29.8 cm), framed

Alex Walter
Broken Arc, 2010
Acrylic paint and oil pastel on canvas
30 x 39 ¾ in. (76.2 x 101 cm)

JORGE "EL CHE" FIGUEROA
(b. 1943, Guatemala City)
Lives in Philadelphia, Pennsylvania

Untitled, 2000-2010
20 black-and-white gelatin silver prints
Each: 12 x 15 in. (30.5 x 38.1 cm), framed

GARY A. FREITAS
(b. San Francisco, California)
Lives in Phoenix, Arizona

Singularity: Operating System (OS): 1.0, 2010
Acrylic paint and computer components
44 x 44 x 7 in. (111.8 x 111.8 x 17.8 cm)

Singularity: Operating System (OS): 1.1.0, 2010
Acrylic paint and computer components
30 x 30 x 12 in. (76.2 x 76.2 x 30.5 cm)

Singularity: Operating System (OS): 1.2.0, 2010
Acrylic paint and computer components
50 x 50 x 13 in. (127 x 127 x 33 cm)

**SYLVIA GRAY
WITH THE ELSEWHERE
COLLABORATIVE**
(b. 1917, Mount Airy, North Carolina; d. 1997)
Elsewhere Collaborative founded 2003

Natural History, 2010
Archived object installation, and hand-bound book
Dimensions variable

JIM GROSBACH
(b. 1939, New Albany, Indiana)
Lives in Buckeye, Arizona

Megaland Revised Version, 1997
Self-produced bound book
8 x 6 x ½ in. (20.3 x 15.2 x 1.3 cm)

World Book of Facts, 1998
Self-produced bound book
11 x 9 x 1 in. (27.9 x 22.9 x 2.5 cm)

History of Clay Civilization, Vol. 2, 2005
Self-produced bound book
13 x 9 x 1 ½ in. (33 x 22.9 x 3.8 cm)

Between Innings, 2010
Plasticine modeling clay
28 x 24 x 20 in. (71.1 x 61 x 50.8 cm)

NICOLE HARVIEUX
(b. 1981, Edina, Minnesota)
Lives in Rapid City, South Dakota

Tribute to Our Soldiers, 2009–2010
Digital photographs on DVD

WARREN HATCH
(b. 1953, Portland, Oregon)
Lives in Portland, Oregon

Seeds Through a Microscope, 2000
Laminated poster
35 ½ x 24 in. (90.2 x 61 cm)

Bees and Wasps: An Appreciation, 2010
Single-channel color video with sound
66 mins., 44 secs

JAKE HERMAN
(b. 1892, Pine Ridge, South Dakota; d. 1969, Rapid City, South Dakota)

Big Hand, ca. 1960
Oil on canvas board
26 x 31 ¾ in. (66 x 80.6 cm), framed
Courtesy of Sacred Heart Church, Pine Ridge, South Dakota

His First War Party, ca. 1960
Oil on canvas board
21 ½ x 27 ¾ in. (54.6 x 70.5 cm), framed
Courtesy of Sacred Heart Church, Pine Ridge, South Dakota

Horse on Hill, ca. 1960
Oil on canvas board
23 ¾ x 27 ¾ in. (60.3 x 70.5 cm), framed
Courtesy of Sacred Heart Church, Pine Ridge, South Dakota

The Legend of the Seven Campfires, ca. 1960
Oil on canvas board
23 ½ x 28 in. (59.7 x 71.1 cm), framed
Courtesy of Sacred Heart Church, Pine Ridge, South Dakota

The Legend of the Two Eagles, ca. 1960
Oil on canvas board
23 ¾ x 27 ¾ in. (60.3 x 70.5 cm), framed
Courtesy of Sacred Heart Church, Pine Ridge, South Dakota

The Legend of the Wolf Girl, ca. 1960
Oil on canvas board
22 x 28 in. (55.9 x 71.1 cm), framed
Courtesy of Sacred Heart Church, Pine Ridge, South Dakota

MAIZA HIXSON
(b. 1977, Greensburg, Kentucky)
Lives in Philadelphia, Pennsylvania

Men Are Much Harder 2 (Extended),
2006–2010
Single-channel color video with sound
48 mins.

DAVID HOELZINGER
(b. 1954, Tacoma, Washington)
Lives in Phoenix, Arizona

The Calendar, 1970-1996
26 Calendars; Rapidograph pen and
colored pencils on paper
9 x 10 in. (22.9 x 25.4 cm) each

HOWARD KLEGER
(b. 1970, Holland, Pennsylvania)
Lives in Philadelphia, Pennsylvania

Collection of Drawings and Writing,
1996–2010
Pen on paper, paper on wood
Dimensions variable

Howard2Go, 2009
Single-channel color video with sound
73 mins., 22 secs.

ELLEN LESPERANCE
(b. 1971, Minneapolis, Minnesota)
Lives in Portland, Oregon

*Cardigan Worn by Greenham Commons
Women's Peace Camp Activist as She Left
Holloway Prison, Charged with Social
Disruption for the Second Time in Two
Months, Winter 1983*, 2009
Gouache and graphite on paper
23 x 29 ½ in. (58.4 x 74.9 cm)

*Cardigan Worn by Greenham Commons
Women's Peace Camp Activist as She Left
Holloway Prison, Charged with Social
Disruption for the Second Time in Two
Months, Winter 1983*, 2009
Wool
Dimensions variable

*She Stormed the Compound Singing: "Old
and Strong, She Goes On and On, On and
On, You Can't Kill the Spirit, She Is Like a
Mountain,"* 2009
Gouache and graphite on paper
23 x 29 ½ in. (58.4 x 74.9 cm)

*She Stormed the Compound Singing: "Old
and Strong, She Goes On and On, On and
On, You Can't Kill the Spirit, She Is Like a
Mountain,"* 2010
Wool
Dimensions variable

*Sitting and Lying in Front of the Convoy,
They Formed a Blockade That Was 2,000
Women Thick*, 2010
Gouache and graphite on paper
23 x 29 ½ in. (58.4 x 74.9 cm)

*Sitting and Lying in Front of the Convoy,
They Formed a Blockade That Was 2,000
Women Thick*, 2010
Wool
Dimensions variable

CYMANTHA DIAZ LIAKOS
(b. 1963, Manchester, Tennessee)
Lives in Roswell, New Mexico

Back to School, 1974–1975
Marker on paper
13 x 14 in. (33 x 35.6 cm), framed

Meet the Teacher, 1974–1975
Marker on paper
16 x 21 in. (40.6 x 53.3 cm), framed

The Parents Return Home From Trip,
1974–1975
Marker on paper
17 x 21 in. (43.2 x 53.3 cm), framed

Time to Eat, 1974–1975
Marker on paper
16 ½ x 18 ½ in. (41.9 x 47 cm.), framed

People Are Strange, ca. 1976
Marker on paper
19 x 22 in. (48.3 x 55.9 cm), framed

JONATHAN LINDSAY
(b. 1985, Winston-Salem,
North Carolina)
Lives in Winston-Salem,
North Carolina

Christmas at Grandma Pugh's, 2004
Acrylic on panel
18 x 20 in. (45.7 x 50.8 cm)

Uncle Binky, 2006
Acrylic on panel
17 ½ x 21 ½ in. (44.5 x 54.6 cm)

Off to Church, 2007
Acrylic on panel
18 x 20 in. (45.7 x 50.8 cm)

RAYMOND MARIANI
(b. 1984, Bronxville, New York)
Lives in Winston-Salem,
North Carolina

Baker, 2010
Pen and Magic Marker on paper
14 x 15 in. (35.6 x 38.1 cm)

Barber, 2010
Pen and Magic Marker on paper
20 x 14 in. (50.8 x 35.6 cm)

Baseball, 2010
Pen and Magic Marker on paper
14 x 14 in. (35.6 x 35.6 cm)

Bus Driver, 2010
Pen and Magic Marker on paper
15 x 14 in. (38.1 x 35.6 cm)

Conducting, 2010
Pen and Magic Marker on paper
14 x 15 in. (35.6 x 38.1 cm)

Construction Worker, 2010
Pen and Magic Marker on paper
14 x 15 in. (35.6 x 38.1 cm)

Dentist, 2010
Pen and Magic Marker on paper
14 x 15 in. (35.6 x 38.1 cm)

Director, 2010
Pen and Magic Marker on paper
15 x 14 in. (38.1 x 35.6 cm)

Doctor, 2010
Pen and Magic Marker on paper
14 x 15 in. (35.6 x 38.1 cm)

Farmer, 2010
Pen and Magic Marker on paper
14 x 15 in. (35.6 x 38.1 cm)

Fireman, 2010
Pen and Magic Marker on paper
14 x 15 in. (35.6 x 38.1 cm)

Hot Dog Man, 2010
Pen and Magic Marker on paper
14 x 15 in. (35.6 x 38.1 cm)

Lumberjack, 2010
Pen and Magic Marker on paper
20 x 14 in. (50.8 x 35.6 cm)

Magician, 2010
Pen and Magic Marker on paper
14 x 15 in. (35.6 x 38.1 cm)

Mailman, 2010
Pen and Magic Marker on paper
14 x 15 in. (35.6 x 38.1 cm)

Moving Man, 2010
Pen and Magic Marker on paper
20 x 14 in. (50.8 x 35.6 cm)

Oil Man, 2010
Pen and Magic Marker on paper
20 x 14 in. (50.8 x 35.6 cm)

Painter, 2010
Pen and Magic Marker on paper
20 x 14 in. (50.8 x 35.6 cm)

Plumber, 2010
Pen and Magic Marker on paper
11 x 14 in. (27.9 x 35.6 cm)

Policeman, 2010
Pen and Magic Marker on paper
14 x 15 in. (35.6 x 38.1 cm)

Shoemaker, 2010
Pen and Magic Marker on paper
20 x 14 in. (50.8 x 35.6 cm)

Taxi Driver, 2010
Pen and Magic Marker on paper
14 x 20 in.

Teacher, 2010
Pen and Magic Marker on paper
14 x 15 in. (35.6 x 38.1 cm)

ALAN MASSEY
(b. 1984, West Philadelphia,
Pennsylvania)
Lives in West Philadelphia

Line Composition Series, 2010
Five plastic laminate chips, vinyl wall
covering, craft tape, magazine paper
4 x 2 ½ in. (10.2 x 6.4 cm), each

JENNIFER MCCORMICK
(b. 1970, Bloomsburg, Pennsylvania)
Lives in Winston-Salem, North
Carolina

Medical Demonstrative Evidence,
2006–2010
Three commercial inkjet prints
40 x 30 in. (101.6 x 76.2 cm), each

JIM MCMILLAN
(b. 1946, Charlotte, North Carolina)
Lives in Winston-Salem, North
Carolina

Chillin', Ellerbe, N.C., ca. 1980
Archival dye inkjet print
15 x 20 in. (38.1 x 50.8 cm)

Bryan, Andy, Adam, Horseshoe, N.C., ca.
1990
Archival dye inkjet print
15 x 20 in. (38.1 x 50.8 cm)

*Drinking by the River, Montgomery Co.,
N.C.,* 1996
Archival dye inkjet print
15 x 20 in. (38.1 x 50.8 cm)

**BEATRICE MOORE
AND THE MUTANT
PIÑATA SHOW**
(b. 1950, Dallas, Texas)
Lives in Phoenix, Arizona

Chris Clark
Bird Etiquette (Part Two), 2010
Papier-mâché, feathers, paint,
newspaper
24 x 24 x 12 in. (61 x 61 x 30.5 cm)
Courtesy of Susan Copeland

Tom Cooper
Singin' th' Xplfnt Blues Ag'in, 2010
Cardboard box, tissue paper, mylar,
acrylic paint
22 x 22 x 8 ½ in. (55.9 x 55.9 x 21.6 cm)

Ana Forner
Snowman, 2009
Newspaper, tissue, paste
53 x 60 x 60 in. (134.6 x 152.4 x 152.4 cm)

Mike Maas
Vampire P.S.A., 2010
Corrugated cardboard, acrylic, spray
paint, gold leaf, pipe cleaner
36 x 27 x 19 in. (91.4 x 68.6 x 48.3 cm)

Koryn Woodward Wasson
Go Felt a Fish, 2008
Felt, papier-mâché, glue
24 x 24 x 28 in. (91.4 x 68.6 x 48.3 cm)

DENNIS NEWELL
(b. 1969, Roseburg, Oregon)
Lives in Portland, Oregon

Lego Battle with Droids and Clones, 2010
Legos and lights
20 x 20 x 10 in. (50.8 x 50.8 x 25.4 cm)

BOB NEWLAND
(b. 1948, Belle Fourche, South Dakota)
Lives in Hermosa, South Dakota

...And Stay the Hell Off, 1984
Black-and-white negative paper, Giclée
print, archival paper
11 x 14 in. (27.9 x 35.6 cm)

*Been a Long Time Since We Rock-and-
Rolled,* 1983
Black-and-white negative paper, Giclée
print, archival paper
11 x 14 in. (27.9 x 35.6 cm)

Horsefly, 1982
Black-and-white negative paper, Giclée
print, archival paper
11 x 14 in. (27.9 x 35.6 cm)

Keepin' Kids off Drugs in South Dakota,
1983
Black-and-white negative paper, Giclée
print, archival paper
11 x 14 in. (27.9 x 35.6 cm)

Oh. There's my Hat, 1982
Black-and-white negative paper, Giclée
print, archival paper
14 x 11 in. (27.9 x 35.6 cm)

Rumble at the Corn Crib, 1983
Black-and-white negative paper, Giclée
printe, archival paper
11 x 14 in. (27.9 x 35.6 cm)

JOSEPH PEREZ
(b. 1986, Phoenix, Arizona)
Lives in Phoenix, Arizona

Poetry in Motion, 2010
Single-channel color video with sound
9 mins., 19 secs.

Sound in Color, 2010
Acrylic on primed canvas
48 x 84 x 3 in. (121.9 x 213.4 x 7.6 cm)

Sound in Color: Friday Night, 2010
Acrylic on primed canvas
48 x 84 x 3 in. (121.9 x 213.4 x 7.6 cm)

BERNIE PETERSON
(b. 1948, Worthington, Minnesota)
Lives in Rapid City, South Dakota

*Soap Carvings: Buffalo, Hand, Foot, Cat,
Soap Dish, Chain,* 1983–1994
Soap
Approx. 2 ½ x 4 x 1 ½ in. (6.4 x 10.2 x 3.8
cm), each

BRUCE PRICE
(b. 1953, Pine Ridge, South Dakota;
d. 2011, Rapid City, South Dakota)

Walter Davidson Circa 1903, 2005
Watercolor on paper
18 x 24 in. (45.7 x 61 cm)

Indian, 2006
Marker and watercolor on paper
12 x 14 in. (30.5 x 35.6 cm)

60 Below, 2010
Acrylic on paper
27 x 41 in. (68.6 x 104.1 cm)

House of the Rising Sun, 2010
Acrylic on paper
18 x 24 in. (45.7 x 61 cm)

DAVID ROSENAK
(b. 1957, San Francisco, California)
Lives in Portland, Oregon

Untitled, 1995–2000
Oil on plywood
11 x 12 ⅞ in. (27.9 x 32.8 cm), framed

Untitled, 1998, 2008
Oil on plywood
16 x 27 ⅞ in. (40.6 x 70.9 cm), framed

Untitled, 1998–2008
Oil on plywood
5 ⅜ x 5 ⅜ in. (13.7 x 13.7 cm), framed

Untitled, 2007
Oil on plywood
5 ¾ x 6 ⅞ in. (14.6 x 17.5 cm), framed

Untitled, 2008
Oil on plywood
7 ¾ x 7 ½ in. (19.7 x 19.1 cm), framed

Untitled, 2009
Oil on plywood
8 ¾ x 11 ⅛ in. (22.2 x 28.2 cm), framed

JJ ROSS
(b. 1992, Clackamas, Oregon)
Lives in Damascus, Oregon

Dragon King, 2010
Marker and pencil on paper
11 x 8 ½ in. (27.9 x 21.6 cm)

The Evil Robot, 2010
Marker and pencil on paper
11 x 8 ½ in. (27.9 x 21.6 cm)

Evil Spiky, 2010
Marker and pencil on paper
11 x 8 ½ in. (27.9 x 21.6 cm)

Ghosts Reaching Out, 2010
Marker and pencil on paper
11 x 8 ½ in. (27.9 x 21.6 cm)

The Good Mrs. Pete, 2010
Marker and pencil on paper
11 x 8 ½ in. (27.9 x 21.6 cm)

Jack & the Nasty Robot, 2010
Marker and pencil on paper
11 x 8 ½ in. (27.9 x 21.6 cm)

Michael Jackson's Music Lives On, 2010
Marker and pencil on paper
11 x 8 ½ in. (27.9 x 21.6 cm)

Mini–Me Terrorizing, 2010
Marker and pencil on paper
11 x 8 ½ in. (27.9 x 21.6 cm)

Mr. Frog and the Romance, 2010
Marker and pencil on paper
11 x 8 ½ in. (27.9 x 21.6 cm)

Rick & James Singing, 2010
Marker and pencil on paper
11 x 8 ½ in. (27.9 x 21.6 cm)

Super Grandma Adventure, 2010
Marker and pencil on paper
11 x 8 ½ in. (27.9 x 21.6 cm)

Super Mom Surrounded, 2010
Marker and pencil on paper
11 x 8 ½ in. (27.9 x 21.6 cm)

Todd and Maximum, 2010
Marker and pencil on paper
11 x 8 ½ in. (27.9 x 21.6 cm)

Tossing the Fish, 2010
Marker and pencil on paper
11 x 8 ½ in. (27.9 x 21.6 cm)

Who Says You Are Only Young Once, 2010
Marker and pencil on paper
11 x 8 ½ in. (27.9 x 21.6 cm)

ANDREW SGARLET
(b. 1984, Wilkes-Barre, Pennsylvania)
Lives in Philadelphia, Pennsylvania

Bible, 2009
Oil on linen
14 ¼ x 10 x 1 ⅜ in. (36.2 x 25.4 x 3.6 cm)

GPS, 2009
Oil on linen
8 ½ x 7 x 1 ½ in. (21.6 x 17.8 x 3.8 cm)

Phone Book, 2009
Oil on linen
13 ¼ x 10 x 1 ⅜ in. (33 x 25.4 x 3.6 cm)

Natural Area, 2010
Oil on linen
12 x 16 x 1 ⅜ in. (30.5 x 40.6 x 3.6 cm)

Yellow Pages, 2010
Oil on linen
15 x 10 x 1 3/8 in. (38.1 x 25.4 x 3.6 cm)

ROBERT SMITH-SHABAZZ
(b. 1949, Philadelphia, Pennsylvania)
Lives in Philadelphia, Pennsylvania

Miles Davis, 1998
Pencil and lacquer on carved wood
11 ½ x 8 x ⅜ in. (27.9 x 20.3 x 1 cm)

Elijah Muhammad, 2002
Watercolor on carved wood
9 ½ x 6 ½ x ½ in. (24.1 x 16.5 x 1.3 cm)

Martin Luther King, Jr., 2002
Watercolor on carved wood
9 ½ x 6 ½ x ½ in. (24.1 x 16.5 x 1.3 cm)

Venus + Serena Williams, 2003
Watercolor and laquer on wood
11 x 8 x ¾ in. (27.9 x 20.3 x 1.9 cm)

Tupac, 2007
Watercolor on carved wood
11 ¼ x 8 ½ x ½ in. (28.6 x 21.6 x 1.3 cm)

The Obama Family, 2009
Water and acrylic on wood (round
from tree)
Approximately 20 x 18 x 2 ½ in.
(50.8 x 45.7 x 6.4 cm)

RUDY SPEERSCHNEIDER
(b. 1972, Detroit, Michigan)
Lives in Portland, Oregon

*The History of Junior Ambassador's Food
Cart: A Mostlandian Venture*, 2007–2009
Remnants of a mobile food cart, sig-
nage, ephemera, food, love and friend-
ship index, community, Mostlandia
72 x 72 x 72 in. (182.9 x 182.9 x 182.9 cm)

ANDREA SWEET
(b. 1961, Brady, Texas)
Lives in Avondale, Arizona

Shade, 2010
Photographs, dolls, postcards, mixed
ephemera
Dimensions variable

JAMES WALLNER
(b. 1976, Omaha, Nebraska)
Lives in Redfield, South Dakota

Masters—1985, n.d.
Pencil on paper
11 x 8 ½ in. (27.9 x 21.6 cm)

Masters in Color, n.d.
Pencil, crayon and marker on paper
11 x 8 ½ in. (27.9 x 21.6 cm)

Masters—1982, 2003
Pencil and crayon on paper
14 x 11 in. (35.6 x 27.9 cm)

Masters—1983, 2004
Pencil on paper
11 x 8 ½ in. (27.9 x 21.6 cm)

PRESLEY H. WARD
(b. 1947, Louisburg, North Carolina)
Lives in Greensboro, North Carolina

Untitled, 2004
Paint and yarn on wood
53 x 7 in. (134.6 x 17.8 cm)
Collection of Steve Sumerford

The Transition Time Ark Has Arrive, 2005
Graphite, colored pencil, and crayon
on paper
11 x 8 ½ in. (27.9 x 21.6 cm)

Untitled, 2007
Paint on wood
60 x 2 in. (152.4 x 5.1 cm)
Collection of Steve Sumerford

Untitled, 2007
Paint on wood
51 x 4 in. (129.5 x 10.2 cm)
Collection of Beth Sheffield

I Got to Find a Way to End This Illusion,
2008
Graphite, colored pencil, and crayon
on paper
17 x 14 in. (43.2 x 35.6 cm)

Industrial Disease, 2008
Graphite, colored pencil, and crayon
on paper
17 x 14 in. (43.2 x 35.6 cm)

Passion Circuitry, 2008
Graphite, colored pencil, and crayon
on paper
17 x 14 in. (43.2 x 35.6 cm)

Wards Subconscious Mind Mechanics, 2008
Graphite, colored pencil, and crayon
on paper
17 x 14 in. (43.2 x 35.6 cm)

Man What a Dream I Had, 2009
Graphite, colored pencil, and crayon
on paper
14 x 17 in. (35.6 x 43.2 cm)

Pandora Jar, 2009
Graphite, colored pencil, and crayon
on paper
17 x 14 in. (43.2 x 35.6 cm)

Peggy Sue Celebrate Her 16th Birthday,
2009
Graphite, colored pencil, and crayon
on paper
14 x 17 in. (35.6 x 43.2 cm)

The City First Drawing, 2009
Graphite, colored pencil, and crayon
on paper
17 x 14 in. (43.2 x 35.6 cm)

The Psychosis Delusions Village, 2009
Graphite, colored pencil, and crayon
on paper
14 x 17 in. (35.6 x 43.2 cm)

Untitled, 2009
Paint on wood
49 x 5 ¾ in. (124.5 x 14.6 cm)
Collection of Beth Sheffield

PAUL WILSON
(b. 1963, Phoenix, Arizona)
Lives in Phoenix, Arizona

*Dick & Dottie Kimble's Family Photo
Album, 1947 to ?*, 1993–1997
Handcrafted photo collages with
colored pencil and marker
24 x 36 in. (61 x 91.4 cm)

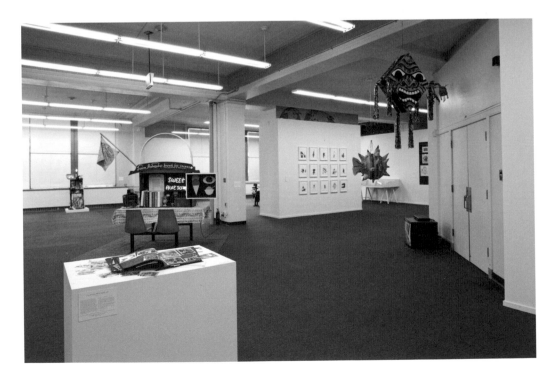

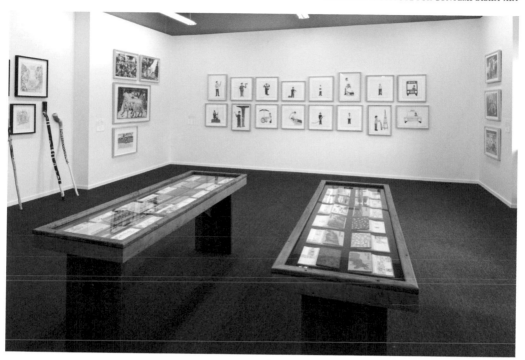

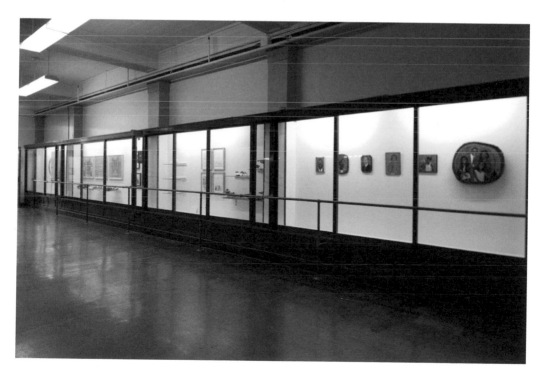

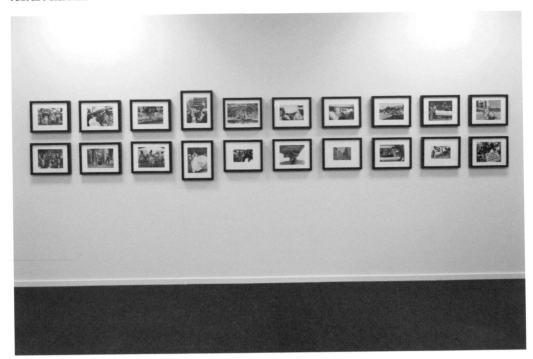

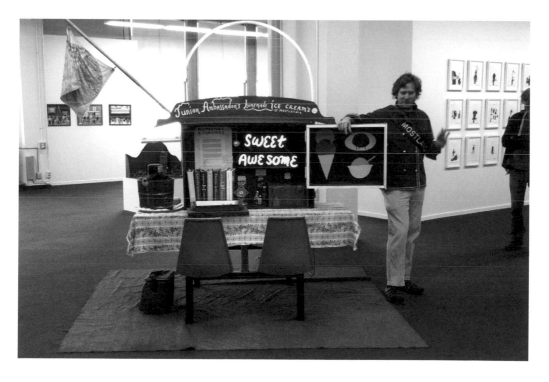

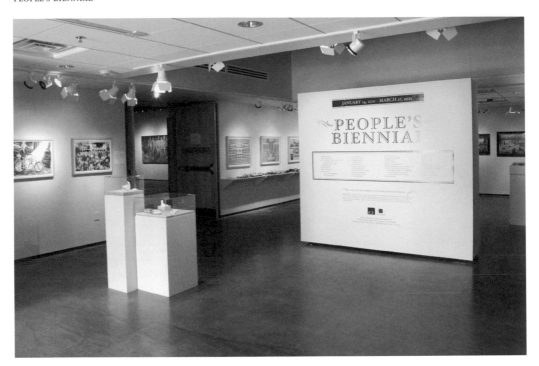

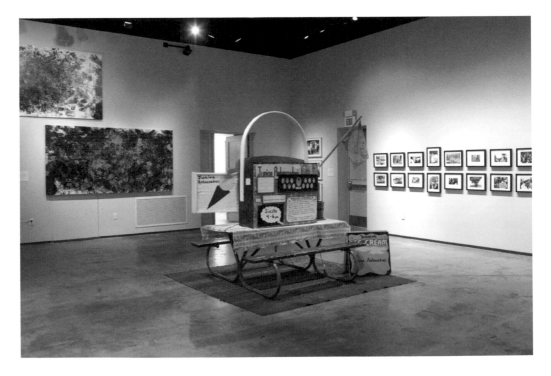

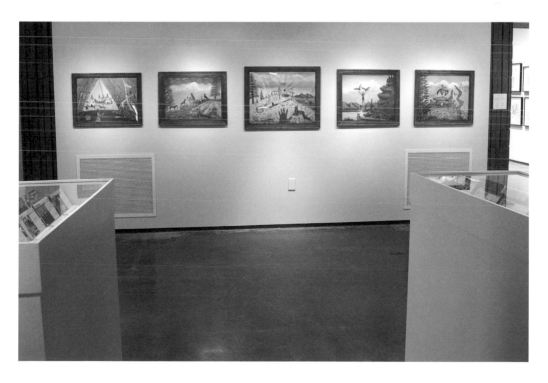

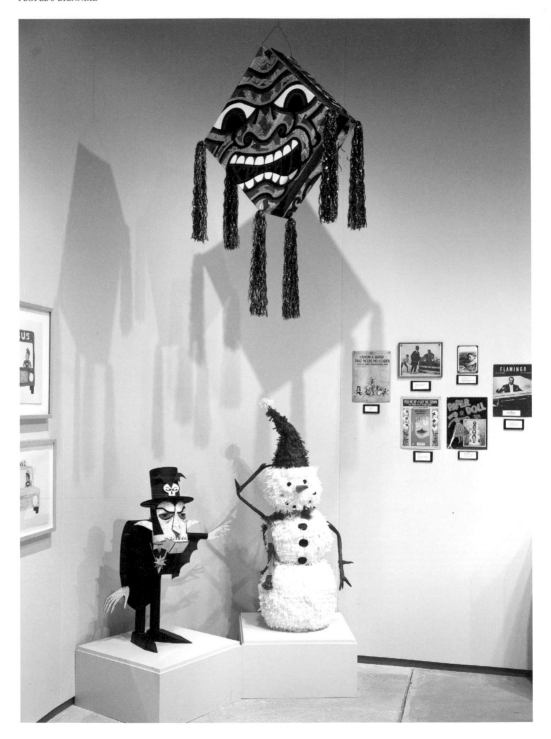

PHOTO CREDITS
AND THANK YOU'S

Photo credits: pgs. 1, 2, 3, 4, 5, 132, 133, 134, 135, 136: Steve Babbitt; pgs. 28, 29, 122, 123, 124, 125: courtesy of Portland Institute for Contemporary Art; pg. 31: Dan Kvitka; pgs. 33, 35, 37, 39, 41, 43, 46, 47, 49, 55, 57, 59, 61, 63, 69, 71, 73, 77, 79, 85, 87, 89, 91, 93, 95, 97, 103, 105, 107, 109, 111, 113, 115, 117, 126, 127, 128, 129: Mike Wolforth; pg. 51: Mary Bordeaux; pg. 53: Nicole Harvieux; pgs. 66, 67: Cliff Dossel and Michael Christiano; pg. 75: Jennifer McCormick; pg. 82: Peter Bugg; pg. 83: courtesy of Scottsdale Museum of Contemporary Art; pgs. 100, 101: Steve Magnotta Intrigue Photography

Many thanks to those who helped make the *People's Biennial* events and exhibition a communal success:

Portland, Oregon:
PICA staff, Victoria Frey (Executive Director), Patrick Leonard (Communications Director), Kent Richardson (Head Preparator), Tesar Freeman (Preparator), Claire LaMont (Preparator), Rebecca Steele (Curatorial Assistant), Adriane Cloepfil (Curatorial Intern), Claire Papas (Curatorial Intern); Bill Boese from Morning Becomes Electric; Dave Kuretich and Larry Gorham from WS Construction; Ace Hotel, Portland; half/drop repeats

Rapid City, South Dakota:
The Dahl Arts Center staff; The Dahl Arts Center Exhibits Committee and other tireless volunteers, Ray Tysdal, Lynn Thorpe, Denise DuBroy, Jean Selvy-Wyss, Loren Miles, Paul Peterson, Steve Babbitt, Peter Strong, Mary Bordeaux, Jessica Kerlin, Tracey Armstrong, Jami Guthrie, Michael Bruce, Callie Tysdal, Dwayne Wilcox, Gail Damin, Pete Hopkins; The FUNd at Black Hills Area Community Foundation; Sacred Heart Center, Pine Ridge; Oglala Lakota College, Piya Wiconi Campus, Kyle; The Heritage Center at Red Cloud School, Pine Ridge

Winston-Salem, North Carolina:
SECCA staff, Mark Richard Leach (Executive Director), Michael Christiano (Curator of Education), Cliff Dossel (Registrar and Installation Manager), Endia Beal (Former Program Assistant), and Ellen Wallace (Marketing and Public Relations Manager); Enrichment Center staff, Valerie Vizena (Executive Director), Shayna Parker (Visual Arts Instructor), Sue Kneppelt (Director, Gateway Gallery); Krankies Coffee staff, Mitchell Britt (Co-Owner and General Manager), John Henry Bryan (Co-Owner); Green Hill Center for the Arts staff, Laura Way (Executive Director), Edie Carpenter (Director of Artistic and Curatorial Programs); David Ford from WFDD (WakeForest University Radio)

Scottsdale, Arizona:
SMoCA staff, Tim Rodgers (Director), Lesley Oliver (Marketing and PR), Alex Moquay (Director of Development), Val Ryan (Development Coordinator), Diana Bergquist (Graphic Designer), Kenny Barrett (Community Outreach Assistant), Pat Evans (Registrar), Laura Best (Exhibitions Manager), Lauren O'Connell (Curatorial Coordinator), Christine Htoon (Intern); SMoCA's Artist Advisory Committee and other local artists; Sue Chenoweth (Educator of Advanced Visual Arts, Metropolitan Arts Institute); Cyndi Coon (Owner Laboratory 5 and Adjunct Professor, Arizona State University, Tempe); Angela Ellsworth (Assistant Professor of Intermedia, Arizona State University, Tempe); Suzanne Falk; Saskia Jorda (Director of Taliesin Artist Residency Program, Taliesin West); Tara Logsdon (EKLbearmy); Adria Pecora (Professor of Art and Art History, Paradise Valley Community College, Phoenix); Gregory Sale (Visiting Assistant Professor of Intermedia, Arizona State University, Tempe); John Spiak (Curator, Arizona State University Art Museum, Tempe); Susan Rubin (Corporate and Foundation Stewardship Coordinator, Arizona Science Center); Amy Silverman (Managing Editor, Phoenix New Times Magazine); Steve Jansen (Night & Day Editor/Staff Writer, Phoenix New Times Magazine)

Haverford, Pennsylvania:
Haverford College Humanities Center staff, Israel Burshatin (Director), Emily Cronin (Associate Director), James Weissinger (Associate Director), John Muse (Faculty Curricular Liaison, Exhibitions Program), Ruti Talmor (Mellon Postdoctoral Fellow); David Richardson (People's Biennial Student Project Coordinator); Cantor Fitzgerald Gallery Assistants, Darren White, Yani Chu-Richardson, Rachel Lim, Aubree Penney; Haverford College Communications staff, Sebastianna Skalisky, David Moore, Jennifer O'Donnell; Dorothy Labe (Director, Haverford Campus Center); Daniel Fuller at Philadelphia Exhibitions Initiative; Steve Magnotta and Christopher Rocco (Intrigue Photo); Duncan Cooper (Soo Good); Sarah Jacoby and Vicky Funari (Videographers); Karen Lefebvre-Christou and art2love; Ellis Ferrell and the Fletcher Street Riding Club; The Institute of Contemporary Art, University of Pennsylvania staff, Lucy Gallun, William Hidalgo, Nikyia Rogers; Elizabeth Grimaldi & The Village of Arts and Humanities; Veronica Castillo-Perez and Melissa Yarborough, Raices Culturales Latinoamericanas, Inc.; Daniel DeJesus, Taller Puertorriqueño; Michaelanne Harriman, Ayuda Community Center; Pat McBee and Friends Center; K-Fai Steele and Jen Rice; Julius Scissor

Jens Hoffmann would like to personally thank: Clarie Fitzsimmons, Adriano Pedrosa, Sophia Hoffmann, Luisa Lambri, Hans Ulrich Obrist, Micki Meng, Jana Blanckenship, Vincent Worms, Alex Matson, Steve Beal.

Harrell Fletcher would like to personally thank: Wendy Red Star, Beatrice Red Star Fletcher

And thanks to all of the many artists who shared their work with us.

Finally, we wish to express our sadness at the untimely death of artist Bruce Price (1953-2011) to whom we dedicate this publication.

## COLOPHON

Published to accompany the traveling exhibition *People's Biennial,* produced by Independent Curators International (ICI), New York

Exhibition curated by
Harrell Fletcher and Jens Hoffmann

Exhibition Funders
The exhibition, tour, and catalogue are made possible in part by grants from The Andy Warhol Foundation for the Visual Arts, The Cowles Charitable Trust, The Elizabeth Firestone Graham Foundation, and The Horace W. Goldsmith Foundation; the ICI Board of Trustees; and ICI Benefactors Barbara and John Robinson.

Exhibition Itinerary
Portland Institute for Contemporary Art
Portland, Oregon
September 10, 2010–October 17, 2010

The Dahl Arts Center
Rapid City, South Dakota
January 14, 2011–March 27, 2011

Southeastern Center for Contemporary Art
Winston-Salem, North Carolina
July 8, 2011–September 18, 2011

Scottsdale Museum of Contemporary Art
Scottsdale, Arizona
October 15, 2011–January 15, 2012

Cantor Fitzgerald Gallery, Haverford College
Haverford, Pennsylvania
January 27, 2012–March 2, 2012

Independent Curators International (ICI)
401 Broadway, Suite 1620
New York, NY 10013
Tel: 212-254-8200
Fax: 212-477-4781
www.ici-exhibitions.org

Library of Congress
2011922424

ISBN
978-0-916365-83-7

Editors
Harrell Fletcher, Jens Hoffmann, and Renaud Proch

Copy Editors
Lindsey Westbrook and Diego Hadis

Designer
Stripe SF / Jon Sueda with Megan Lynch

Publication Coordinator
Frances Wu Giarratano

Printer
Overseas Printing / Printed in China

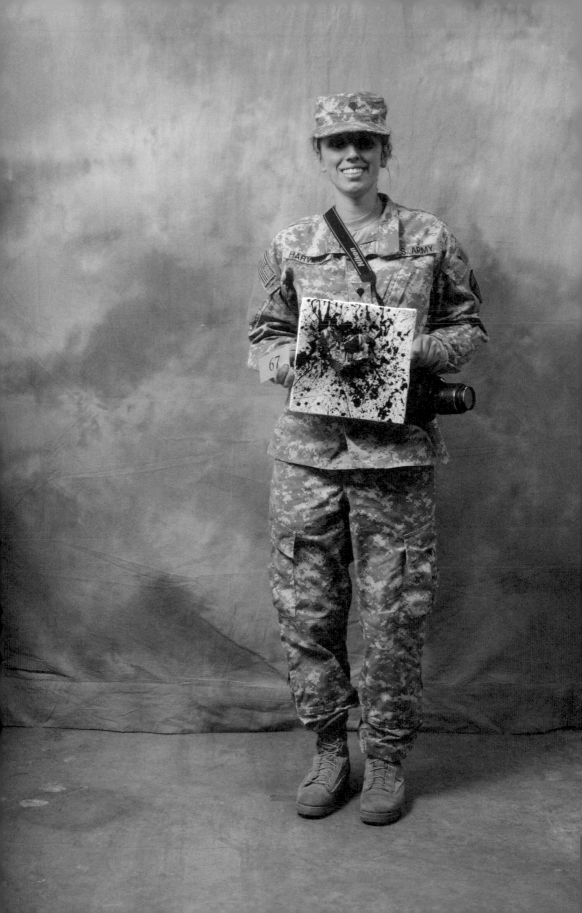